Portrait of –

STOCKPORT

John Creighton

Sigma Leisure
Wilmslow

First published in 1989
Reprinted 1990, 1994

Sigma Leisure an imprint of **Sigma Press** 1 South Oak Lane, Wilmslow, SK9 6AR, England.

British Library Cataloguing in Publication Data

An information card has been lodged with the British Library in respect of this title.

ISBN: 1 85058 135 5

Typesetting by: Sigma Hi-Tech Services Ltd
Printed by Manchester Free Press

Acknowledgments

The Author took many of the modern photographs used in this book. He would like to extend his thanks to the following who also provided photographs:-

Stockport Metropolitan Borough Libraries, who supplied many of the older illustrations; Robinson's Brewery; the Davenport Theatre; the Headmaster of Stockport Grammar School; Colin Davies; British Aerospace; Simon Engineering.

Contents

Next Page:
Mersey Square looking towards Manchester
with the A6 in the background

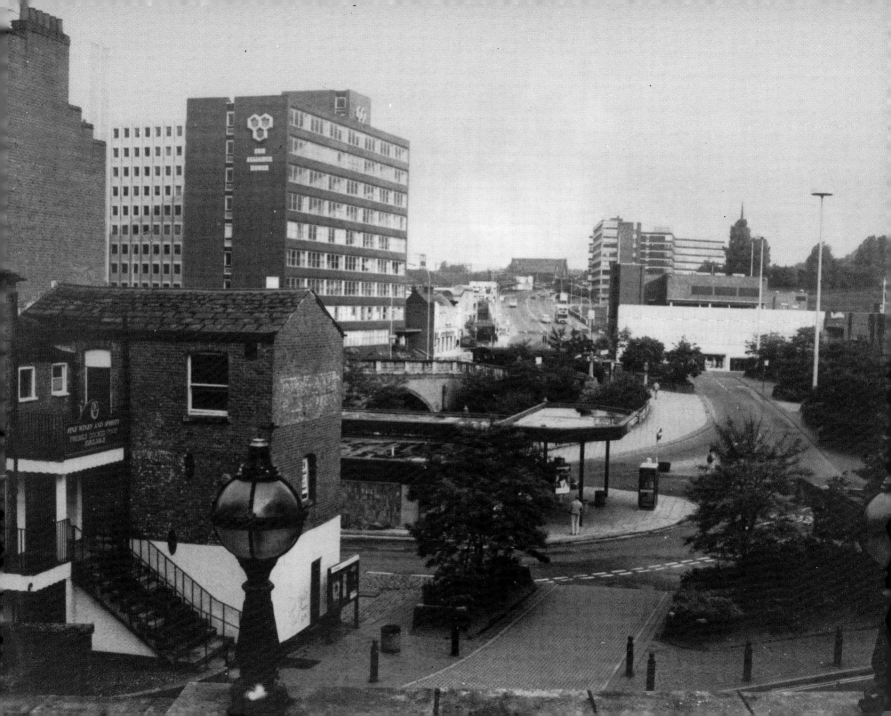

1. Introduction

Stockport is situated at the confluence of the Rivers Tame and Goyt which join to form the River Mersey. Manchester lies seven miles to the north while the Pennine foothills are located to the east of the town. The undulating Cheshire countryside is a few miles south, and is described in the Author's book - *'Cheshire - A Portrait in Words and Pictures'*.

Much conjecture surrounds the origins of the name Stockport. Some would argue that it dates from the Anglo-Saxon *'Stoc-port'*, while others link it with the Stokeport family. It is clear, however, that in the 12th century it was written as *'Stopport'* and it appeared in a 15th century deed as *'Stopford'*. During the Civil War when occupied by Parliamentary troops from the surrounding area the place was referred to as *'Stopworth'*. Many pundits would suggest that this crossing place on the River Mersey was originally called *'Stockford'*.

Positioned on the Mersey and at the heart of a national communications network, Stockport is as much a natural focal point as it was in Roman days and before. The community of some 300,000 residents can enjoy the town's industrial heritage, historic halls, 700 year old market and the nearby rugged Pennine scenery.

History and Development

Bronze Age artefacts have been discovered in north Cheshire and the Stockport area, and it is likely that there is a link between Celtic settlements and traces of moats in the region. In fact, the name Mersey is thought to be a derivation of the Celtic word *'Marusia'*.

The town's origins are associated with a ford across the Mersey at Tiviot Dale. This crossing was guarded by the 240 million year old red sandstone cliff on which the market place is situated. There is no absolute proof that the Romans knew the district well but it may be reasonably assumed that they made full use of the ford. This established Stockport as an important spot on the route south from Manchester. Examples of other Roman roads included one from Glossop, while a further route linked up with the Buxton-Chester road.

It is probable that the site on Castle Hill was the base for Roman troops who favoured the natural defensive position. That the Romans were here is supported by an 18th century discovery of a Roman coin dating from the time of Emperor Honorius (AD 393-423).

The legacy of Danish occupation of the district is found in several local place names such as Cheadle Hulme and Levenshulme, south Manchester. 'Hulm' is said to be a Danish by-form of the common Scandinavian word 'holm' - land surrounded by streams or rivers. 'Holmer' means an island or fen.

There is no mention of 'Stockport' in the Domesday Survey of 1086, although references are made to Norbury, Bramhall and Cheadle. However, it is clear that there was a Norman castle at 'Stokeport' in 1173, held by Geoffrey de Costentin who was one of King Henry II's sons. In the 13th century the Spencers as Earls of Winchester granted the castle and the barony of Stockport to the de Stokeport family. The castle was located in Castle Yard on the market place and appeared to comprise a basic moat with rudimentary tower. The castle gradually fell into a state of disrepair and it is likely that it was reduced to ruins when used as a defensive position in the Civil War. Interestingly, a section of the town wall can still be found behind shops on Great Underbank.

A charter of freedom of Stockport was granted to Sir Robert de Stokeport by Randle III, Earl of Chester in 1220. Forty years later a second charter gave the right to hold a weekly market and an annual fair. By the end of the 14th century the Warren family of Poynton had become Lords of the Manor which remained in their possession until they sold the baronial and manorial rights to the Corporation of Stockport in 1850.

Moving on to the 15th century, Stockport Grammar School was founded in 1487 by Sir Edmund de Shaa (see Chapter four). About two centuries later, on his march through Lancashire and Cheshire, Prince Rupert captured the town in 1644 with 10,000 troops, defeating and driving across the Mersey 3,000 Parliamentary troops under the local commander, Colonel Duckenfield.

During Charles II's reign 168 people succumbed to the plague which swept through England. 1745 saw Prince Charles and his retreating army arrive in Stockport, and local sources indicate he may have stayed in the town.

In 1775 Sir George Warren, Lord of the Manor, ordered the destruction of Stockport Castle ruins and he built a round tower on the site. This was demolished in 1841 to make room for the market.

An interesting event took place in 1784 when one Jonathan Thatcher rode a cow around the market. The beast had a saddle and bridle and the demonstration was aimed against the injustice of a Saddle Tax. Mr Thatcher from Woodbank became a local folk hero who was featured in rhyme and in paintings as he protested against Prime Minister Pitt's tax.

When the Romans left, the Saxons built a village on the site, and by later Anglo-Saxon times a small market community had evolved on top of the sandstone spur. This gave rise to the name 'stoc-port' - the hamlet at a market.

The early 1700s brought the silk industry to Stockport with some 2,000 people employed in six mills by 1740. The first mills in England engaged in winding and rolling silk were set up in Stockport, mainly along the Tin Brook. With the advent of the cotton industry silk soon disappeared from the scene as early cotton mills utilised power provided by the waters of the Mersey, Carr, Goyt, Tame and Tin Brook.

Samuel Oldknow made an impact on the industrial scene in the 1790s, establishing a mill by the Goyt, sinking coal mines and constructing lime kilns on Strines Road. The discontent surrounding the Corn Laws is well documented and numerous meetings took place in Stockport. In fact, some 5,000 Stockport residents were in attendance at the so-called Peterloo disturbances of 1819 in Peter's Fields, Manchester.

It was about this time that low wages encouraged strike action by the Jenny spinners and power-loom weavers of Stockport. Demonstrations and processions took place, and in 1819 the Riot Act was read and the Yeomanry had to disperse a crowd in Sandy Brow.

The first issue of the 'Stockport Advertiser' went on sale in 1822, priced seven pennies. 1826 saw the opening of Wellington Road - following two years of work on the route from Heaton Chapel to Bramhall Lane.

The Infirmary on Wellington Road South first admitted patients in 1832. It was designed in the classical Greek style by Richard Lane.

The next few decades introduced important developments in public transport. Stockport viaduct opened in 1840, encouraged by an 1837 Act of Parliament which authorised the Manchester and Birmingham Railway to construct a line from Manchester to Crewe. This would be via Stockport and Sandbach. Travellers were further assisted by the opening of Edgeley Station in 1843 and the one at Tiviot Dale in 1865. During 1878 Stockport Corporation built a line from the town centre connecting with the Manchester Tramways. The first horse-drawn trams from Manchester to Stockport commenced service in 1880, and 1901 brought the inauguration of a new electric tram route to Woodley via Vernon Park and Bredbury.

Stockport was made a County Borough in 1889, the year when the Technical School opened. The Prince of Wales attended the opening ceremony of the Town Hall in 1908, while the Central Library was completed four years later. Just after World War One started the Cheshire Volunteer Regiment was formed and in 1915 the Grammar School moved to premises in Davenport.

As World War Two looked imminent extensive bomb shelters were constructed in Chestergate, and in fact bombs fell on the town in 1940.

The Merseyway Shopping Precinct dates mainly from 1968 and runs from Mersey Square to Warren Street.

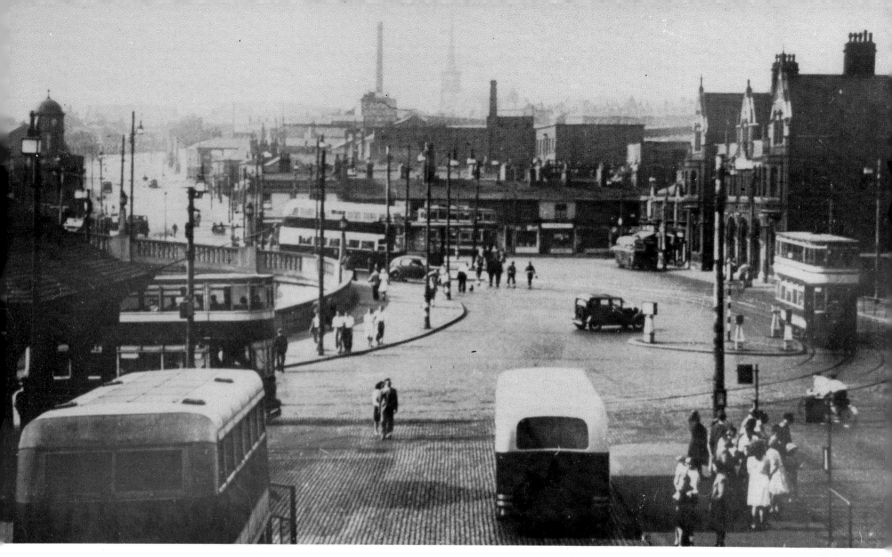

The Metropolitan Borough of Stockport came into existence in 1974, incorporating the urban districts of Bredbury and Romiley, Cheadle and Gatley, Hazel Grove, Bramhall and Marple.

In 1982, the M63 arrived in the town centre, with an extension at Portwood started in 1987. Perhaps one of the most visible changes to Stockport's image was the clean-up of the viaduct on which work began in 1988.

Trams operate alongside buses in this 1946 view of Mersey Square, which was formerly called Carr Green.

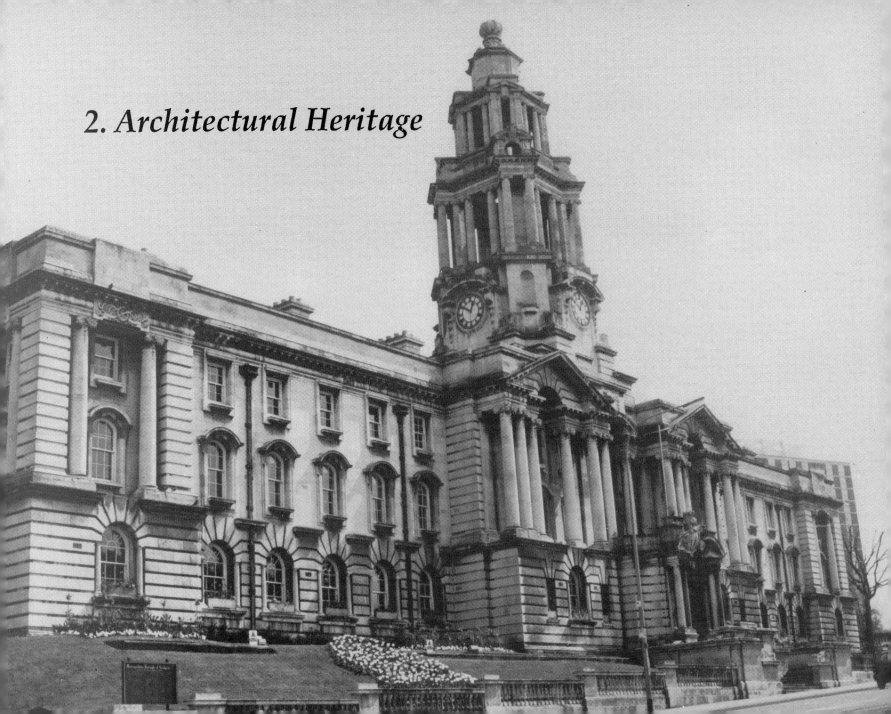

2. Architectural Heritage

This chapter refers to some of Stockport's well known landmarks like the Town Hall, Underbank Hall and Bramall Hall. It is hoped that attention will be drawn to the contrasting styles of architecture found within the borough, ranging from the majestic Lyme Hall to Stockport Viaduct. Many of the town centre buildings date from the late 18th and early 19th centuries and little remains in terms of half-timbered structures.

The town helps to promote its older buildings by offering financial assistance, early 1989 seeing a loan provided by the Architecture Heritage Fund. This was made available to restore one of Stockport's oldest domestic buildings, the Staircase Café, now commonly known as Staircase House. The cruck-framed structure dates from the second half of the 15th century and it contains a number of 17th century and 18th century oak-panelled rooms.

Facing page:
The imposing Stockport Town Hall, constructed between 1904-1908, was opened by the Prince of Wales, who later became King George V.

The Town Hall

Just over 80 years ago the Prince and Princess of Wales officiated at the opening of Stockport's 'wedding cake' style Town Hall. Prince's Street was in fact named after the Prince to commemorate this event.

Prior to the construction of the Town Hall, the offices of Stockport Corporation were situated in various premises throughout the town. Sir Brumwell Thomas' design was agreed on in 1904, with the foundation stone being laid in October of that year. The final stone was put in place in 1907 at the top of the 130 foot high clock tower. Chimes were not provided in case patients were disturbed in the Infirmary just across the road.

The Renaissance style Town Hall has an entrance which opens onto an impressive double stairway. There are numerous panelled rooms in the building, and the Council Chamber features a richly domed ceiling on segmental arches.

Several stained-glass windows depict important people in Stockport's history including Robert de Stokeport and Randle de Blundeville, Earl of Chester. The Mayoral Suite is located under the clock tower and a 60 foot corridor leads to the large Hall or Ballroom which accommodates 1,250 people for meetings or concerts.

Some Stockport people know that the Hall was employed as a hospital in World War One. In the Second World War it housed refugees from the Channel Isles.

Visitors can admire an impressive collection of silver and plate, some of which dates to the 15th century. There is a small studio link with BBC Radio and this is often used for live interviews with local people.

Stockport's War Memorial and Art Gallery dates from 1925. It occupied the site of the Grammar School before it moved to Davenport.

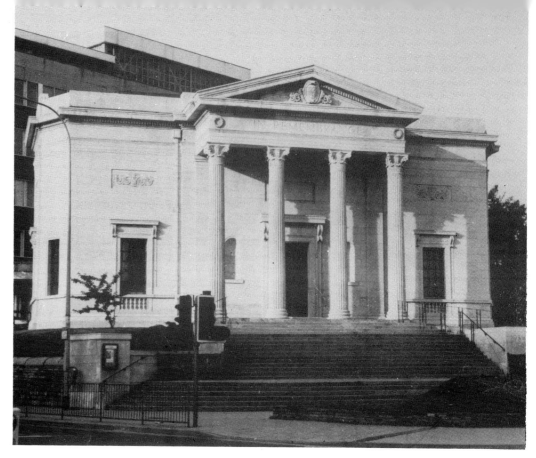

The War Memorial and Art Gallery

How many commuters on the A6 realise that the War Memorial and Art Gallery on Greek Street was once the site of Stockport Grammar School? The move to Buxton Road took place in December 1915 and the Grammar School's old buildings were used as a Central School and Evening School. In 1923 the site was cleared and presented to the town for the erection of a War Memorial and Art Gallery which stands there today.

The imposing entrance portico has four Corinthian columns and the inscribed message above these reads 'In Remembrance'. Built in 1925 by J.T. Halliday, this classical design was popular in Victorian and Edwardian times.

The Gallery presents visual arts in an approachable and exciting manner, its exhibitions including comic and cartoon art forms, photographic displays, landscapes and murals.

The Central Library

Occupying a prominent position on Wellington Road South, the Library was constructed in 1912-13 by Bradshaw, Gass and Hope. It was built at a cost of £15,000 on the site of the old Mechanics' Institute and one principal external feature of note is the corner dome.

This was not the first library in the town. The Free Library, over the Market Hall was opened in 1875 with extensions taking place ten years later.

Underbank Hall

The imposing black and white timber-framed building on Underbank is now occupied by a bank. The structure dates from the late 15th or early 16th century, and was the town house of a local gentry family, the Ardernes of Bredbury, who also owned Harden or Ardern Hall, Bredbury, for over 300 years. They are said to be related to William Shakespeare through his mother, Mary Arden.

Considerable alterations to the building occurred during the Tudor period when a fine chimney piece and impressive oak staircase were added.

This two storey timber-framed building features a delightful porch, several gables plus exterior decorations of diamond shapes and crosses set diagonally.

The Three Shires

The Three Shires building is now used as offices and a wine bar. One wonders how many customers consider the history of this place as they sip a dry white wine. The two gabled structure with its black and white frontage was a section of the town house of another Cheshire gentry family, the Leghs of Adlington. It was later occupied by a member of the Tatton family.

The Market Place

Standing with your back to the Market Hall and looking at the western end of the market place will reveal an intriguing blend of architectural styles. Above the Yorkshire Building Society one can see a mock Tudor building, and alongside there is a structure dating from the late 1800s. The angels' heads on the decorated frontage give a clue as to this building's earlier rôle as a pub named 'The Angel Inn'. It started serving ale in 1824 and closed in 1951. (See Chapter Seven, 'Breweries and Pubs'.)

The red brick edifice next door features ornate moulded decorations, while the adjoining building is the former Produce Market. Built in 1852 by Stevens and Park, this place was originally one-storeyed. The upper section with its Corinthian Style columns was added in 1875 to accommodate the Free Library. The next building is a fine example of a Georgian structure whose façade was rebuilt in the mid-1980s.

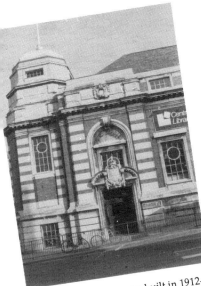

The Central Library was built in 1912-13. A Free Library began business in the market place on September 20th, 1875.

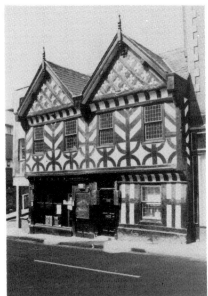

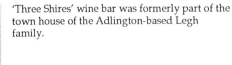

'Three Shires' wine bar was formerly part of the town house of the Adlington-based Legh family.

Moulded terracotta decorates this building in the market place.

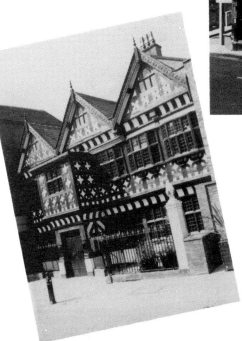

Underbank Hall was once the town house of the Ardern family. It became Stockport's first bank in the early 19th century and today it houses a branch of the National Westminster Bank.

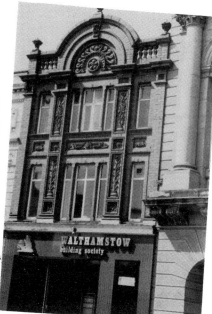

Dating from 1852, the former Produce Market was the work of Stevens and Park.

The Covered Market

The cast-iron and glass covered market occupies the site of the former open market. Dating from 1861, the interesting building was modified in 1912 when a section of the side furthest away from the church was removed. This was done to enable a trolleybus route to go through the market-place. Interestingly, the company which built the covered market, Emmerson and Murgatroyd, also constructed a similar one in Malta, again during 1861. The covered market initially had no sides, and it was not until 1894 that the sides were filled in, following protestations by one Ephraim Marks of Marks and Spencer fame.

Of course, time took its toll on the Victorian market hall which had become very rusty by the 1960s. The transformation of the hall from an unsightly hulk to the elegant building it is today has proved a great success. In April 1988 those responsible for the scheme were awarded certificates by the Civic Trust at Stockport Town Hall.

The Underbanks and Lower Hillgate

Lower Hillgate was a popular medieval thoroughfare, and today it contains a collection of buildings dating from the 18th and 19th centuries.

In the Underbanks and Lower Hillgate there are quaint shop fronts and buildings constructed from the red sandstone foundations of the town. 'Turner's Vaults' dated from the mid-1700s and provided many a drink for thirsty shoppers over the years.

St. Petersgate Bridge is a good vantage point from where Little Underbank can be examined from above. Built in 1868, it links the Market Place with High Bank Side and features an interesting cast iron section. The bridge also carries the Stockport Borough Coat of Arms. The earlier Coat of Arms dates to the 1830s while the armorial bearings in use today were granted in 1932, with the supporters awarded in 1960.

Perhaps one of the most unusual buildings in Little Underbank is the famous Clock House. The front section has the sign 'Winter's Jewellers' and there are animated figures dating to the 1800s. These have chimed the hour for over one hundred years. The property was occupied by the jewellers for many years. However, in 1988 the current owners spoke of demolishing the landmark. This followed a decision by Stockport Licensing Justices not to grant permission for a wine bar on the site. Of course, local opposition to demolition and redevelopment was considerable.

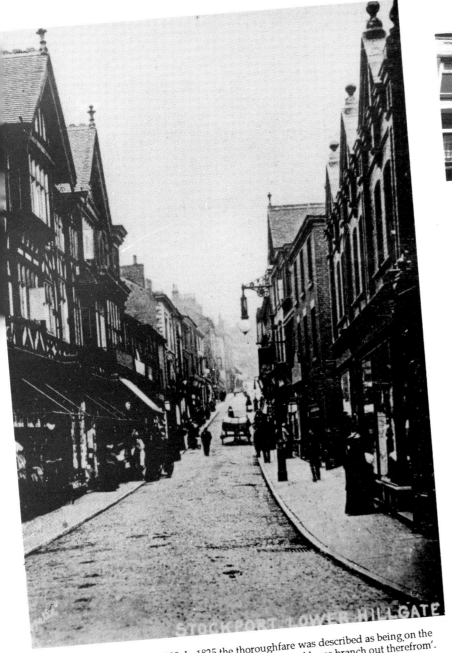

Lower Hillgate in 1900. In 1825 the thoroughfare was described as being on the London Road, 'from whence numerous streets and lanes branch out therefrom'.

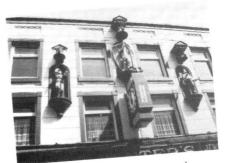

Winter's Jewellers has a most intriguing display of animated figures on a façade which dates from the late 1800s.

The 1913 scene indicates that the covered market and its environs have changed little over the years.

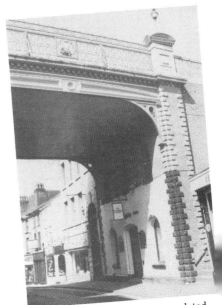

St Petersgate Bridge was completed in 1868 and joined the market place to High Bank Side. A good view of Little Underbank may be obtained from the bridge.

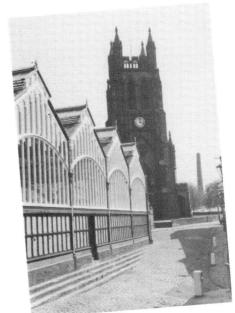

Considerable restoration work was carried out on the covered market in 1984.

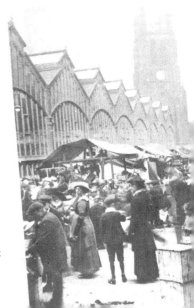

The Old Rectory and 'The Thatched House'

A stroll through the Churchgate area will reveal these two buildings. It is clear that a rectory has occupied this site since the late 17th century, and students of 18th century town architecture would profit from a trip round the Old Rectory which dates from 1744. This five-bay house comprises an imposing doorway with columns together with a semi-circular fanlight. Following the outbreak of World War Two the rectory was the headquarters of the 6th Cheshire Regiment, later becoming the home of the Bishop of Stockport in the 1950s before being purchased by Stockport Corporation.

'The Thatched House' is a short distance from the Rectory. Constructed in 1899 it replaced a thatched timber-framed house which served as the town's first dispensary, beginning its duties in 1775. 'The Thatched House' became a public house selling Wilson's beer.

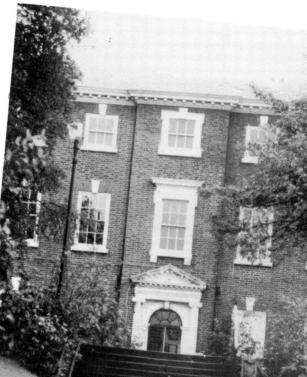

Visitors to the Old Rectory are greeted by Georgian style windows and an impressive doorway.

'The Thatched House' is shown here selling beer, but between 1774 and 1832 it acted as Stockport's first dispensary.

The Cobden Statue

St. Peter's Square is the home of a statue of Richard Cobden who became MP for Stockport in 1841. Well known for his work in connection with repealing the Corn Laws, Cobden also campaigned against the misuse of child labour in factories.

He was not a native of Stockport, coming from Sussex, but he had strong links with the north west. In 1839 Cobden was one of the founders of the Anti-Corn Law League which was formed in Manchester. The League was instrumental in having the Corn Laws repealed in 1876, with both Cobden and John Bright playing major rôles in this work. Elected as Liberal MP for Stockport in 1841, Cobden represented the West Riding of Yorkshire six years later, much to the chagrin of Stockport residents who would have preferred him to remain in their area.

The bronze statue rests on a base of Aberdeen granite and was erected in 1886, the work of G.G. Adams. The eight-foot high figure of Cobden depicts him holding a scroll, while a carving of corn and fruit serves as reminder of his involvement with the Corn Laws and the Free Trade movement.

The 15 ton monument arrived by rail at Edgeley Goods Station in 1886 and was transported to St. Peter's Square and lowered onto the granite pedestal. A time capsule placed under the statue contained some local newspapers, a portrait of the Mayor and coins for the year 1886. Daughter Jane Cobden unveiled the statue in front of a large crowd and this was followed by reception for some 200 people at the Pendlebury Memorial Hall.

The monument remained in its original spot until 1965 when a new road scheme necessitated its moving to a place a few metres away.

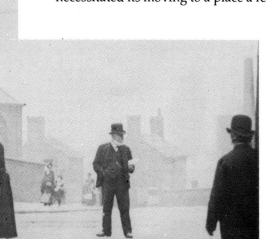

Cobden's Statue in the early 1900s. In 1841 he was elected to represent Stockport in the House of Commons.

The Stockport Viaduct

Dominating the Stockport skyline, this massive viaduct underwent a major clean up in the late 1980s. But why was it built in the first place? In order to provide a through route from Manchester to London, the Manchester and Birmingham Railway was instructed to build a line from Manchester to Crewe. This was authorised by an 1837 Act of Parliament which stipulated that it should go via Stockport.

To accomplish this it was necessary to bridge the River Mersey in Stockport. Operations commenced in 1839 on a viaduct designed by John Lowe who worked with engineer George Watson Buck. Records indicate that construction carried on night and day and involved over 500 men on a shift system.

Naturally, the foundations were of paramount importance and so 20 feet was excavated below ground level. Gigantic slabs of masonry from Runcorn were placed in the holes, forming the base of the piers. Two of these had to be built in the River Mersey, necessitating the construction of coffer dams.

Once the piers were finished the arches began to take shape, first constructed over timber structures which were then removed. Work progressed slowly and methodically from the Heaton Norris end, and the efforts of engineers and workmen culminated in an opening ceremony on 21st December, 1840. The final stone was placed on a parapet by the Chairman of the Railway Director's Board. On the following day site workers were treated to food and old ale at the nearby 'George Inn'.

Initially the line catered for passenger traffic only, and in 1843 Edgeley Station replaced the one at Heaton Norris. By May 1842 the line took passengers as far as Sandbach and soon afterwards a through route was opened from Manchester to Birmingham.

The two tracks carried some 400 trains a day in the late 1880s and it soon became apparent that two extra lines were required to ease congestion. These were added to the west side of the structure, coming into use in 1889.

During the last 160 years little maintenance work has been necessary. In 1929 a defective arch was repaired and the work for electrification took place in 1960 when overhead cable gantries were set up on the viaduct.

The spruce up of Britain's biggest viaduct cost in the region of £3m when work commenced in 1988. There was some controversy concerning the funding of the venture but this was soon resolved. The result of the cleaning is that the original colour of the bricks used over a century ago can be seen, as Stockport viaduct was restored to its original state.

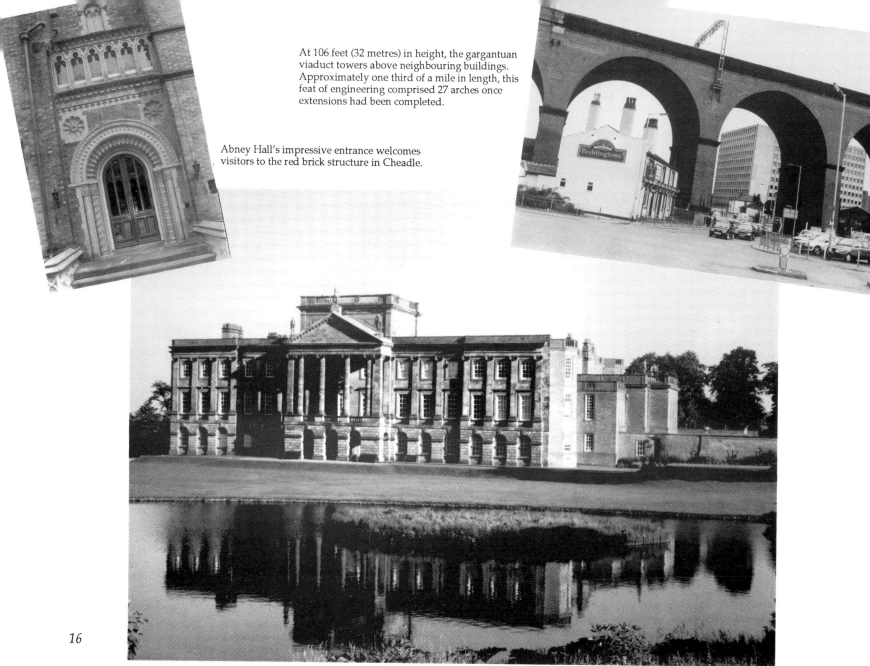

At 106 feet (32 metres) in height, the gargantuan viaduct towers above neighbouring buildings. Approximately one third of a mile in length, this feat of engineering comprised 27 arches once extensions had been completed.

Abney Hall's impressive entrance welcomes visitors to the red brick structure in Cheadle.

There are fifteen bays and a four-column portico on Lyme Hall's south side.

Abney Hall

A Tudor-Gothic style large red-brick house nestling in pleasant grounds just outside Cheadle, Abney Hall has a most impressive interior. Much of this is the work of John Gregory Grace whose legacy dates from 1852-1857. There is also a chandelier by Hardman, Minton tiles in the rooms and a staircase with an open well.

The Manchester wholesaler James Watts, who had a warehouse in Portland Street (see the Author's book, *'Portrait of Manchester'*), bought the house and extended it in 1849. Further sections were added in 1893.

Lyme Hall

On leaving the busy A6 near Disley, the traveller is taken by surprise as he enters Lyme Park with its 1300 acres of wild moorland. Amid the beauty of the Park one discovers lakes, woods, sheep and the famous red deer roaming the grassy landscapes.

Perched 1200 feet above sea-level, Lyme Park is, of course, the location of the magnificent Lyme Hall. Steeped in history, it was for 600 years the seat of the Leghs of Cheshire. Today it belongs to the National Trust and is managed by Stockport Council. Visitors came from many places including Manchester, Stockport, Cheshire and Derbyshire. The grounds and gardens are described elsewhere in this book. (See Chapter Three, 'Leisure and Pleasure'.)

The approach from the main road takes the visitor past a square tower on a hill, Lyme Cage. The actual Hall was constructed of gritstone hewn by hand from the quarries on the estate. The most appealing side is the Italian South with its 15 bays and a four-column portico overlooking a picturesque lake. On the north front of Lyme Hall the original medieval entrance still forms the centre-piece.

This extensively renovated Elizabethan mansion dates from 1560 and is one of the north west's finest stately homes. Among other things, it is famous for its rare Mortlake tapestries and wood carvings by Grinling Gibbons. Visitors can also enjoy rococo plasterwork, rare glassware, period furniture, exquisite paintings and fine portraits. The renowned Legh Collection of antique English clocks is well worth examining and this third most important private collection in the UK provides examples of superb work of such master craftsmen as Thomas Thompson. The Clock Collection was the result of years of studying horology by Sir Francis Legh, former Equerry to the Queen Mother and Treasurer to Princess Margaret. The fascinating exhibition is of national importance, illustrating how clocks changed the way we live today.

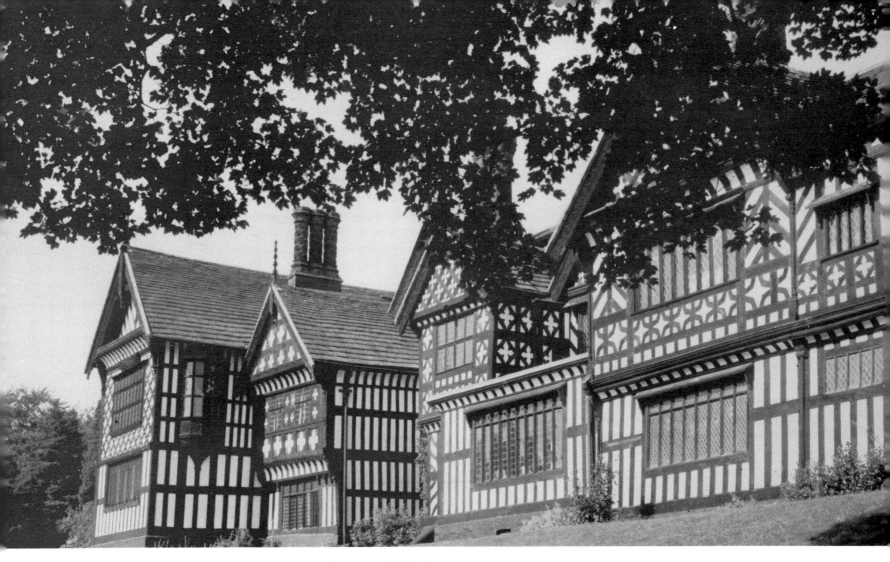

The elegant Bramall Hall epitomises the Elizabethan half-timbered building.

Bramall Hall

Standing in 60 acres of landscaped grounds, this restored half-timbered Elizabethan manor house possesses many attractions. These include Tudor plasterwork, period furniture, intriguing windows and gables, together with the numerous lozenges and cross-shape patterns decorating the exterior.

The name Bramhall derives from the Old English *'brom halh'* which meant a narrow valley where broom bushes were found. Some people would contend that this describes the Lady Brook in Bramhall Park. It is believed that an older hall stood adjacent to the Lady Brook long before the 15th century when some of the earlier sections of today's hall were built.

'Bramale' is mentioned in the Domesday Book and a John de Bromhale is referred to in a deed dated 1260. It is possible that the founder of the de Bromale family was connected to Hamon de Massey, Lord of the Barony of Dunham Massey, who also held Bramhall in the Domesday Survey. He probably received his many lands, including Bramhall, as a reward for good and faithful service to the Earl of Chester.

The Davenports acquired the manor of Bramhall in the 14th century and stayed there for a further 500 years. They supported the Royalists during the Civil Wars and the hall was at one stage occupied by Parliamentary soldiers.

John William Handley Davenport sold the estate to the Manchester Freehold Company in 1877 and six years later the hall and park were purchased by Charles Nevill. In 1935 it was bought by the now defunct Hazel Grove and Bramhall Urban District Council and the hall passed to the Metropolitan Borough of Stockport in 1974. This authority administers and maintains the hall and its grounds.

The Building

The Great Hall. Alice and John Davenport were responsible for the first Great Hall in the late 1300s. This was altered by William and Dorothy Davenport in the 16th century, and it is likely that today's Great Hall is a reconstruction of an older building. Items of interest include an open fireplace with heavy oak surround and the various coats of arms depicted in the painted glass of the windows.

The Lesser Hall. Located on the couth-west side of the Great Hall, this smaller area contains full oak panelling above which one discovers the inscription -
 'Might with fortin and grace, so that proceed to virtue and grace.'
 Charles Nevill reorganised these words so that they appear in the present order. Originally they were jumbled up on the upper panels of this room.

The Library. This has seen considerable refurbishment over the years and the ceiling probably dates from 1800.

The Banqueting Hall. Part of the south wing, this area possibly dates from the 16th century with modifications in the 19th century. Two portraits from 1700 show William and Margaret Davenport.

The Chapel. Here one discovers a pew from the Davenport Chapel in Stockport Parish Church. It is likely the Chapel was constructed at the same time as the south wing. The wall painting on the upper section of the Chapel's west wall shows a cross and Christ's head. The Reformation made such paintings unlawful, and so an attempt was made to obliterate the scene with whitewash. The Ten Commandments were painted over the whitewash in Elizabeth I's time.

The Ballroom. Attention is immediately drawn to the open timber roof and to the wall paintings on the east and north walls of this charming room.

The Plaster Room. Taking its name from the earlier plaster floor, this room occupies the area between the Withdrawing Room and the Chapel Room.

The Chapel Room. Much of the room's appearance dates to the 19th century when Charles Nevill converted it into a billiard room. His crest is above the fireplace and just to the left of it is a sealed door, possibly the entrance to a priest's hiding place.

The Paradise Room. Here one could find a four-poster 'Paradise' bed decorated with tapestry made by Dame Dorothy Davenport. Again, it seems likely that a priest's hiding place may have been concealed behind or next to the fireplace.

The Withdrawing Room. Portraits represent various members of the Davenport family whose ancestry is remembered in the coats of arms in the plaster frieze.
The arms of Queen Elizabeth I are observed above the fireplace, and this probably indicates the Davenport family loyalty for their monarch.

The Davenport Room. A panelled room containing a 'Jacobean' style bed plus a smaller bed. There is a dressing room on the south side and a closet on the north side which could have served as a priest's hiding hole.

Clearly Bramall Hall epitomises the English black and white timbered manor house. Visitors cannot fail to appreciate the grandeur of this building set in 60 acres of landscaped gardens.

3. Leisure and Pleasure

Parks and Walkways

Stockport offers a great deal in terms of leisure and relaxation with one quarter of the borough found in the Green Belt. The town's residents can enjoy some 30 local and district parks and recreation grounds plus 40 allotment sites. There are formal gardens, rural strolls and numerous leisure activities in parklands within a six miles radius of the town centre.

In order to give an insight into Stockport's open spaces, some examples of principal parks and walkways will be considered.

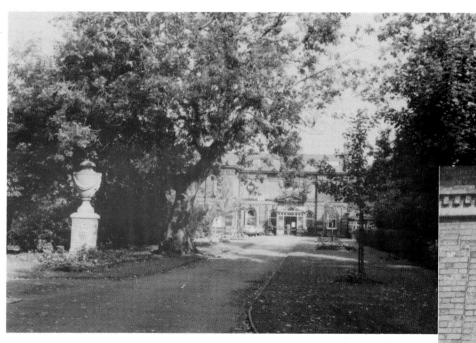

Vernon Park dates to Victorian times and occupies 21 acres.

The inscription above the entrance to Stockport Museum in Vernon Park.

Town Parks

Vernon Park

The town's first public park dates to Victorian times, the land being donated by Lord Vernon when he transferred the manorial rights to the Corporation. The opening of the park took place in 1858, and within its grounds there is one of England's first museums. From Vernon Park there are good industrial and rural views across Reddish Vale, and visitors can enjoy bowling greens and the pleasant rock gardens. Largely unchanged by time, this park still retains much of its charming Victorian atmosphere.

Stockport Museum is located in Vernon Park and provides a fascinating history of the town. For instance, a hat block workshop records Stockport's days as a principal hat-making centre. The upper two galleries of the museum have contained a number of exhibitions, including one which traced the area's history from the earliest signs of human occupation right up to the present. Other attractions include guided tours, lectures and an annual 'Fun Fortnight' of special events in August.

The windows of the museum have a history of their own. Made from 260 pieces of fluorospar taken from the Blue John mines at Castleton, Derbyshire, they are the work of John Tym. He was curator of Vernon Park Museum and his home was in Castleton.

Woodbank Park

This is adjacent to Vernon Park and was presented to the town by Sir Thomas Rowbotham in 1921. The woodlands provide calm places to take a stroll and the spring bloom of rhododendrons is well worth admiring.

Open all year, Woodbank provides a host of sporting activities, while the open spaces and play areas are ideal for family picnics.

Bramhall Park

Of course, the principal attraction here is the majestic hall set amidst 60 acres of tranquil parkland (see Chapter Two). Bramhall Park contains streams, lakes, woods and beautiful gardens. Children will enjoy the playgrounds and nature trail, and snacks are provided in the Stables Café.

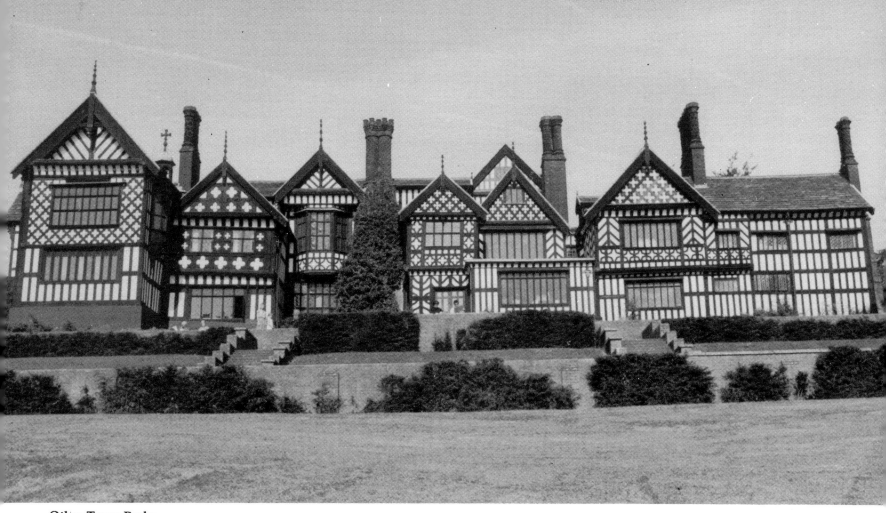

Bramall Park contains the famous hall set amidst 60 acres of parkland.

Other Town Parks

Alexandra Park, Edgeley provides eleven acres of quiet gardens and parkland in a busy suburban area. Opened in 1908, the park contains various recreational facilities, including tennis courts and three bowling greens. BMX enthusiasts can enjoy the track at Bruntwood Park, Cheadle, while less energetic people may wish to visit a pets' corner, the lake, or Bruntwood's attractive gardens.

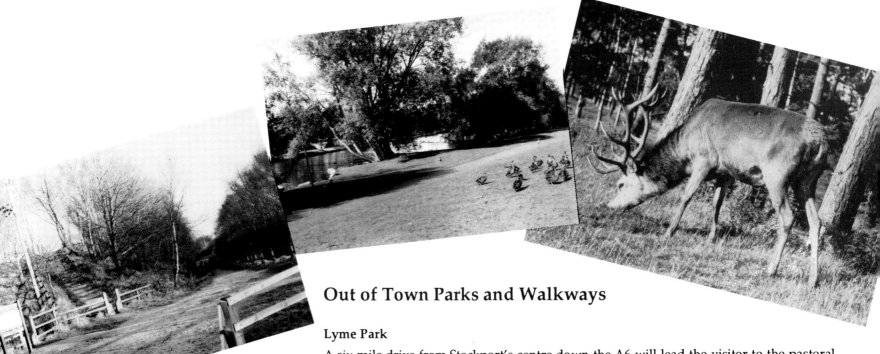

Out of Town Parks and Walkways

Lyme Park

A six mile drive from Stockport's centre down the A6 will lead the visitor to the pastoral Lyme Park near Disley. The hall and park are maintained and administered for the National Trust by Stockport Borough Council. The Legh family owned the 1323 idyllic acres for 600 years, and in 1946 Richard Legh gave the estate to the National Trust.

Lyme's highest point above sea-level is 1200 feet, providing outstanding views of the Peak District, the Cheshire Plain and Pennine foothills. Visitors can enjoy Lyme Hall (see Chapter Two 'Architectural Heritage'), the red deer, formal gardens, nature trails, orienteering courses and Lyme Cage which dates to the 16th century.

The nine day Lyme Festival is held in August and attracts many local and national artists and organisations. Craft exhibitions, music, drama and country pursuits feature in the festival.

Again in August, the renowned Lyme sheep-dog trials bring owners and their animals from all over the north of England, Scotland and Wales to compete in this three day event. The September Lyme horse trials allow competitors to try one of the best novice courses in the region with over 150 riders partaking in this event each year. Of course, Lyme has a great deal to offer outside the summer months. Drawing Room Concerts are popular in December, and the Lyme 600 Classical Concert Series runs from July to October.

Left:

Middlewood Way follows an old railway trackbed and links High Lane with Macclesfield. It runs alongside Lyme Park and the Macclesfield Canal.

Etherow Country Park is rich in wildlife, and the waterways which exist today were built by George Andrew. They were designed to carry water from the weir on the river the turn the mill wheel.

Right:

A Lyme Park stag grazing in the early morning. Lyme Park is stocked with some 240 red deer.

Etherow Country Park

This enchanting 246 acre site at the heart of the Etherow-Goyt Valley is one of Britain's first country parks. Established in 1968 around an old cotton mill, Etherow attracts over a quarter of a million visitors each year. It is the halfway point of the 11 mile Valley Way footpath which connects the centre of Stockport with Woodley Bridge on the Derbyshire border.

Leisure pursuits available at Etherow include bird-watching, nature study, rambling, angling, sailing and model boating. The park is home to over 200 types of plants and over 100 species of birds, while the Keg Woodlands are a favourite haunt of tawny owls. Etherow Country Park was once a section of the estate belonging to George Andrew who built Compstall Mill in the 1820s. In fact, the nearby Compstall Village was erected by him to accommodate the mill workers (see Chapter Eight, 'Some Stockport Districts').

Reddish Vale

A favourite beauty spot for thousands of Stockport residents, Reddish Vale contains clay soil and sand which has encouraged rare plants to flourish. Generations of local people have enjoyed picnics, encouraged to do so by Bluebell Woods, the weir on the River Tame and the impressive 16-arch viaduct. The area featured prominently in the media during the late 1980s when mass protests were held to complain about plans by the GMC Residuary Body to sell off large areas of land on both the Brinnington and Reddish sides of the Tame. The successful campaign by locals saw the land formally transferred to Stockport and Tameside Councils early in 1989.

Other Areas

Brabyns Park nestles in the Goyt Valley, close to Marple Bridge. Visitors can enjoy its woodlands together with a variety of recreational facilities including a pony exercising area.

The Middlewood Way near Stockport is another example of a rural walkway used by many throughout the year. It uses the trackway of a defunct railway line linking High Lane with Macclesfield. The Mersey Valley caters for such diverse interests as fishing, water sports, horse riding and walking.

It is clear therefore, that there is no lack of parks, open spaces and woodlands in Stockport - the gateway to the peaks and the plains of Cheshire.

Entertainment

Cinema, Theatre and Sport

The first recorded exhibition of films was at the New Theatre Royal in 1896, but it was not until October 1910 that a purpose-built cinema came to the town. The 'Stockport Electric Theatre' on Wellington Road South entertained audiences until 1963. The idea of a cinema caught on quickly in Stockport and in 1914 there were 17 in the town, with this number rising to 28 by 1946.

Many cinemas closed or were demolished in later years. For instance, the 'Super Cinema' was pulled down to make way for the GPO main sorting office. Of course, the popularity of television in the 1950s and 1960s led to the demise of many Stockport cinemas. Larger places assumed the rôle of bingo halls, while smaller cinemas were converted to warehouses or garages. It now seems incredible that most of the local picture houses were full most nights of the week before the advent of television. The 'Ritz' had 2,342 seats, the 'Carlton' (later the 'Cannon') accommodated 1,750 people and the Mersey Square 'Plaza' provided seating for 1,873 customers.

One flourishing place of entertainment today is the 'Davenport Theatre' which shows films and has live performances on stage. The official opening of this popular place of entertainment took place in June 1937. Performers appearing on the first night included Mickey's Polo team; Millie Jackson's Streamline Six; Edward Horton and Genevieve Tobin. The opening ceremony was conducted by the mayor of Stockport, Alderman George Padmore J.P.

Mr Edge was the owner until the early 1990s. His father built 32 cinemas in the area in places such as Offerton, Flixton and Gatley where the 'Tatton' also gave its first performance in 1937.

Today, audiences can enjoy films at the two cinemas in the 'Davenport' plus a pantomime and over 40 one-night shows from Ken Dodd, Syd Lawrence and Frankie Vaughan to Freddie Starr, Chubby Brown and Acker Bilk.

Stockport Theatre was located in Park Street and other examples of theatres were found in Heaton Lane and Bridgefield. The Garrick Society dates from the 1860s and a theatre of this name still exists in the town. The Theatre Royal and Opera House, St. Peter's Square began business in June 1888 and was initially run by the Revill family.

The multi-purpose civic centre, Centre Stage, proves attractive to Stockport residents with its live shows, films and theatre. It has also been the venue for the World Professional Snooker and Billiard competitions.

The Theatre Royal no longer exists, although the 'Imperial' next to it is still a popular public house.

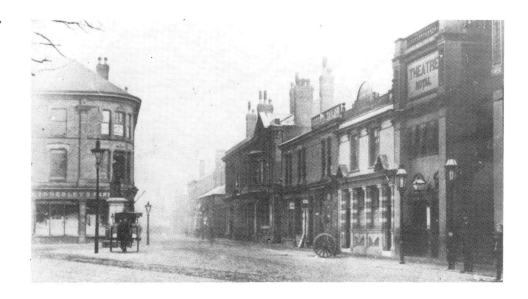

Popular sports in Stockport's past included bull-baiting, cock-fighting and greyhound racing. In fact, the last dog and bull fight took place in 1829 at Whistler's Hollow, Hazel Grove.

Cock-fighting survived in parts of Stockport until 1930, while close to the 'Rising Sun' pub there was a horse race course which was later used for greyhound racing.

The first Stockport Cricket Club was established in 1825 and Stockport County Football Club came into existence in 1890 (see the section on Stockport County Football Club). A century later the town is well provided with outdoor and indoor sports facilities found in 22 recreation centres, swimming baths and sports halls. Stockport is the home of the Metro Swimming Club, ranked a top league club in recent years. Annual sporting events in the borough include an indoor bowls championship and a town centre cycle race.

Early in 1989 plans were revealed for a scheme to build a huge leisure complex on a ten acre site between Stockport Station and Wellington Road. Today, this Grand Central leisure and retail development offers 10-pin bowling, a 10-screen cinema, nightclub, bars, dancing, shops and restaurants.

signal the beginning of a major face-lift for Stockport Station which will take three or four years, and may possibly include a hotel.

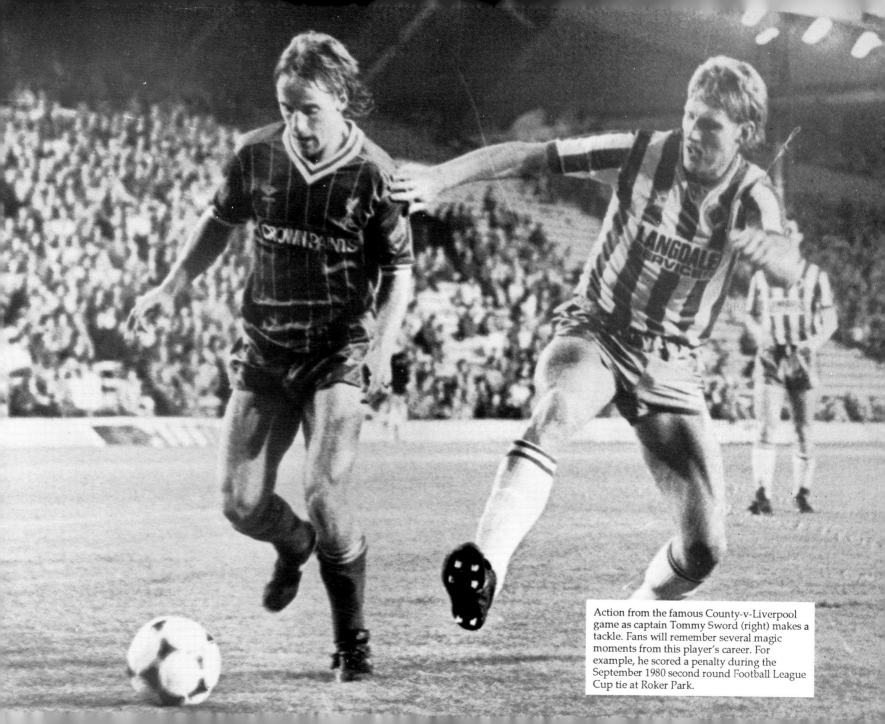

Action from the famous County-v-Liverpool game as captain Tommy Sword (right) makes a tackle. Fans will remember several magic moments from this player's career. For example, he scored a penalty during the September 1980 second round Football League Cup tie at Roker Park.

Stockport County Football Club

Stockport County FC dates from 1890 when the title of Heaton Norris Football Club was changed. This club had formerly played under the name of Heaton Norris Rovers FC which came into existence in 1883. Their ground was situated on Green Lane behind 'The Nursery' public house.

Stockport County FC joined the Football Combination during the 1891/92 season when rivals included Wrexham, Leek, Macclesfield Town and Gorton Villa. The club's first triumph came in 1895/96 as Stockport reached the first round of the FA Cup, only to be knocked out by Burton Wanderers at Green Lane.

A move to the Lancashire League brought success with the club winning the Manchester Senior Cup, thus allowing them to be admitted to the Football League in 1900/1. Here they played alongside Burnley, Woolwich (later becoming Arsenal) and Newton Heath whose name would change to Manchester United. County moved to Edgeley Park in 1902 and supporters eagerly awaited some good results in the new ground.

However, the pressure of Second Division Soccer took its toll with County moving into the Lancashire Combination for one season, returning to the Second Division in 1905/6. They stayed there until the 1912/13 season, and in the early 1900s the club reached the 1st and 2nd rounds of the FA Cup in five successive seasons. The 1920s brought County into competition with giants like Spurs, West Ham and Leeds United. Moving into the newly formed 3rd Division (Northern), Stockport became the first champions of this northern section in 1921/22 and so went up into Division Two for the next four seasons.

Popular crowd pullers of the 1920s included Joe Smith, Harry Burgess and Frank Newton. Unfortunately shortage of cash meant that players had to be sold with one going to Liverpool, while Everton acquired four County players.

The club's second ever championship came in 1936/37 when Stockport defeated rivals Lincoln City to secure promotion to the Second Division. They enjoyed this for only one year, dropping back to Third Division status just as the Second World War broke out. Fans and club officials alike were despondent, particularly as a fire in the mid-1930s had destroyed the main stand.

Following the War, County looked at local players, and soon Billy McCulloch joined the squad following his RAF career at Ringway, while Alec Herd was a former Manchester City player.

County supporters of 40 years ago will remember a record Edgeley gate of 27,833 in February 1950 when Liverpool visited the ground. Unfortunately Stockport lost this match in the FA Cup tie (5th round) but at least the gate receipts totalled £4,300. The 2-1 defeat followed a thrilling match in which the Liverpool players included Joe Fagan and Bob Paisley.

The mid-1950s offered some delights for fans with 1954 bringing the inception of a Supporters' Club, while floodlights were erected at Edgeley two years later.

The club remained in Division Four from 1959-67, then experiencing three seasons in Division Three and dropping back into Division Four in 1970. Perhaps one of the most memorable games of the 1960s was a 4th Round FA Cup tie at Anfield in January 1965 when the Stockport team held Liverpool to a 1-1 draw. White scored for County and Milne gave the Merseysiders their goal. Unfortunately the Edgeley replay saw Liverpool beat their opponents. Fans were not disappointed for long, however, with success coming to Stockport when they became Fourth Division Champions.

Household names associated with the club at this time included Team Manager Eddie Quigley, General Manager Bert Trautmann and goalkeeper Steve Fleet. Jim Wyatt was another popular player who was bought as a striker, and he scored 22 goals in 1967/68. Division Four status came to Edgeley Park in 1970 at a time when fans faced an increase in admission prices from 6 shillings (30 pence) to 10 shillings (50 pence).

During the 1970s, County supporters were treated to some noteworthy Cup ties, mostly in the League Cup with the club reaching round 4 in 1972/73. Stockport's crowds enjoyed Cup matches against Norwich City and Malcolm Allison's Crystal Palace, who had been put out the competition by a single goal from Ray Charter. A League Cup tie against Manchester United in 1978 brought the best out of County who narrowly escaped victory, with the final score reading 3-2.

There was a 3-1 defeat by Arsenal at Edgeley in 1980 with club record receipts totalling £19,382. Stockport fans have been given a number of thrilling matches in the last decade. In 1980, for instance, gate receipts totalled £19,382 at Edgeley Park when the club played Arsenal. The London team won 3-1, with George Wood scoring County's consolation goal.

In the early 1980s, County were beaten by Liverpool in an exciting F.A. Cup game. Under the guidance of manager Danny Bergara Stockport County have been enjoying their most successful spell in their 110 year old history. County were promoted in 1990 into Division Three (now Division Two) and have sinced appeared at Wembley on three occasions, in the Autoglass Trophy (twice) and in the play-off finals of 1992. Unfortunately Wembley turned into a bit of a bogey ground with County losing by the odd goal on all occasions.

4. Churches and Schools

In the first part of this chapter a number of churches will be looked at. It is not intended to give an exhaustive list of places of worship and consequently churches have been chosen from various areas of the borough. Sadly, some chapels and churches have lost their former glory. This is typified by the Mount Tabor Chapel which opened in May 1869 for use by Methodists in Stockport. Demolished in 1969, Mount Tabor could hold 900 worshippers who entered by passing through a Corinthian portico.

In the second section of this chapter, some examples of educational establishment will be examined, in particular the Stockport Grammar School, whose origins date to the 15th century.

Churches

The Parish Church of St. Mary, Stockport

Dominating the market place, this church has sections dating from the 14th century, and in fact the names of rectors appear in local documents from the late 12th century onwards. It is likely that the site has been occupied by a place of worship from Norman times.

The present church's structure initially comprised a nave, tower, aisles and two chancels which were in the Decorated style of Gothic architecture. The chancel is the oldest part of St. Mary's, dating from the 14th century. This is the only surviving section of the original church, and its local red sandstone appearance provides a good indication of how the whole church must have looked.

The remainder of St. Mary's can be traced to the early 1800s when rebuilding was necessary following deterioration of the fabric. When the task was completed in 1817 the church had assumed a predominantly Perpendicular Gothic style of architecture. Further restoration occurred in 1848 when red sandstone replaced masonry which had suffered the ravages of time and weather.

A walk round the exterior reveals examples of the Decorated style, typified by a number of features including the filling-in of the head of windows with trefoils and circles.

The pinnacled church and nearby Rectory both occupy prominent sites from where they can survey Stockport's bustling market and surrounding streets.

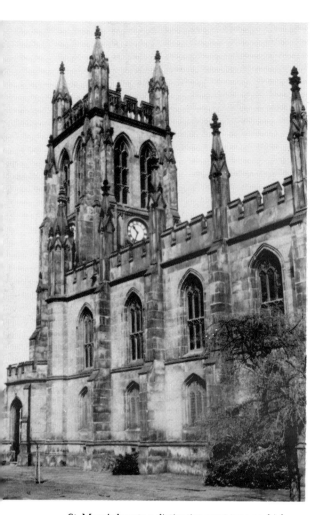

St. Mary's boasts a distinctive west tower which may be glimpsed from many of the roads leading to the market place.

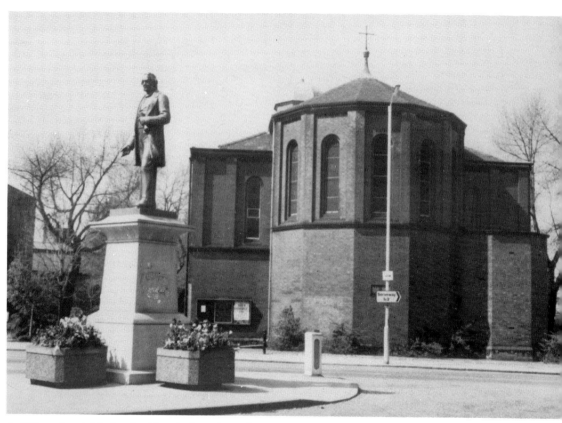

An 18th century brick church with arched windows, St. Peter's is situated close to Cobden's statue.

St. Peter's, Petersgate

Finished in 1768, this brick church was funded by William Wright. Overlooking Cobden's statue, St. Peter's was built to house increasingly large congregations who attended St. Mary's Parish Church. The tower incorporates an octagonal top with the Chancel dating from 1888. The church was consecrated in May 1768 by the Bishop of Chester when some 460 worshippers could be accommodated.

St. Thomas', High Hillgate

Occupying a quiet backwater off Higher Hillgate, this intriguing piece of architecture epitomises the revival of the Greek style. Look at the east end and admire the six fluted Ionic columns. There is a high west tower and the church has two rows of windows. Consecrated in September 1825, St. Thomas' is the work of architect George Basevi.

In 1818 and 1824 Parliament decided to make funds available to build churches in London, Lancashire, Yorkshire and Cheshire. St. Thomas' was the only church built out of the 1818 funds, although several places of worship were erected from the 1824 financial assistance.

St. Joseph's, Tatton Street, Stockport

Hiding down a side street off Petersgate, the 1862 Catholic church is the work of M.E. Hadfield who was also associated with St. Werburgh's, Birkenhead. Although it does not have a tower, St. Joseph's is a pleasing church with its round piers, nave and aisles. This place of worship is an example of Gothic revival style of architecture.

St. Elisabeth's, Reddish

Consecrated in 1883, the church was built by Sir William Houldsworth as part of a community development scheme in Reddish. It was designed by Waterhouse who is perhaps better known for his work on Manchester Town Hall (see the Author's book, 'Portrait of Manchester'). The red brick church exhibits a variety of style such as Byzantine, Norman and Victorian 'Gothic Revival'. Visitors to St. Elisabeth's will see a very high nave, aisles, and a south-east tower with a short spire between pinnacles.

Waterhouse also designed the Rectory, the neighbouring school and an adjacent Working Men's Club. The early part of 1989 brought bad news for St. Elisabeth's. It was estimated that extensive comprehensive restoration would cost half a million pounds, and with only a small congregation of about a hundred worshippers, the vicar had to try and enlist support from local residents and councillors.

St. Joseph's, Reddish

Dating from 1882, this church owes its existence to Joseph Higginson, who donated £5,000 towards the building costs. His memory is perpetuated in a local road bearing his name. Substantial refurbishment and rebuilding occurred in the 1960s when a tower was built adjacent to the new main entrance, and the altar was moved from the east to the west end.

St. George's, Heaviley

Some would argue that this church standing next to the A6 is one of the most magnificent in Stockport. Built in 1896/97 by Austin and Paley, it was funded by a local brewer, George Fearn.

External features incorporate heavy buttresses and embattled walls with a north porch whose doorway sports ornate carvings. The magnificent tower has corner pinnacles where an elegant spire is supported by flying buttresses.

There are two dozen windows in the clerestory, and ceilings inside are most pleasing to the eye. The total height of St. George's is 250 feet and its spire dominates this area of Stockport.

Left:

St. George's is a solid church whose construction includes heavy buttresses and a richly carved north porch.

Right:

St. Mary's, Cheadle is Perpendicular in style. The nave was completed in 1541, while rebuilding of the chancel occurred between 1556-58.

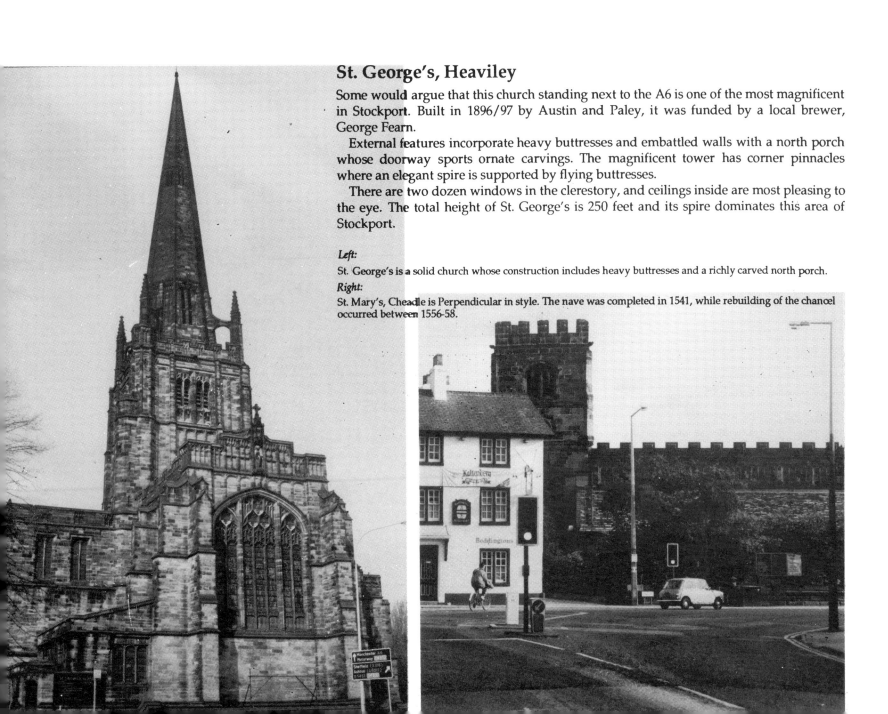

St. Mary's Parish Church, Cheadle

For many commuters the T-junction at 'The White Hart' public house, Cheadle, is just another set of traffic lights on the arduous journey to Manchester. How many motorists have pondered over the origins of the stately church which lies just behind 'The White Hart'?

It was not the original place of worship in the township, since there was a building in existence around the year 1200. This was destroyed by fire in 1520 and replaced by St. Mary's.

The church was constructed over a number of years, the chapel completed in 1530, followed by the nave 11 years later. It was the former Abbess of Godstow, Lady Buckley, who provided funds for rebuilding the chancel in 1558. Both the chapel and clerestory reflect the Perpendicular style of architecture, and the leering gargoyles which peer down from unexpected corners date from the 16th and 17th centuries.

This fine place of worship has two chapels, the one to the south containing delicate stained windows, the one to the north having a 16th century screen referring to Sir John Savage of Rocksavage near Frodsham, lord of Cheadle Hulme and father-in-law of Sir Richard Bulkeley, lord of neighbouring Cheadle Bulkeley.

St. Paul's, Heaton Moor

A Bird and Whittenbury church built between 1876/87, St. Paul's is quite large. Its south-east tower has an octagonal top section.

St. Thomas', Norbury

Records suggest that there may have been a Preaching Cross at Norbury as early as 1005 AD. In 1465 the Lord of the Manor was granted a licence to build a private chapel at Norbury in the area where today's Ashbourne and Darley Roads are found.

The Norbury Chapel dated from the late 16th century, the first reference to it occurring in Stockport Parish registers of 1617 and it was demolished in 1834. The foundation of the Parish Church had been laid in May of the previous year by the Mayor of Stockport. In May of 1835 it held its first confirmation service attended by the Bishop of Chester. The church has rather slender buttresses, a thin west tower and pinnacles on the four corners of the tower. These date from 1884 when restoration was deemed necessary.

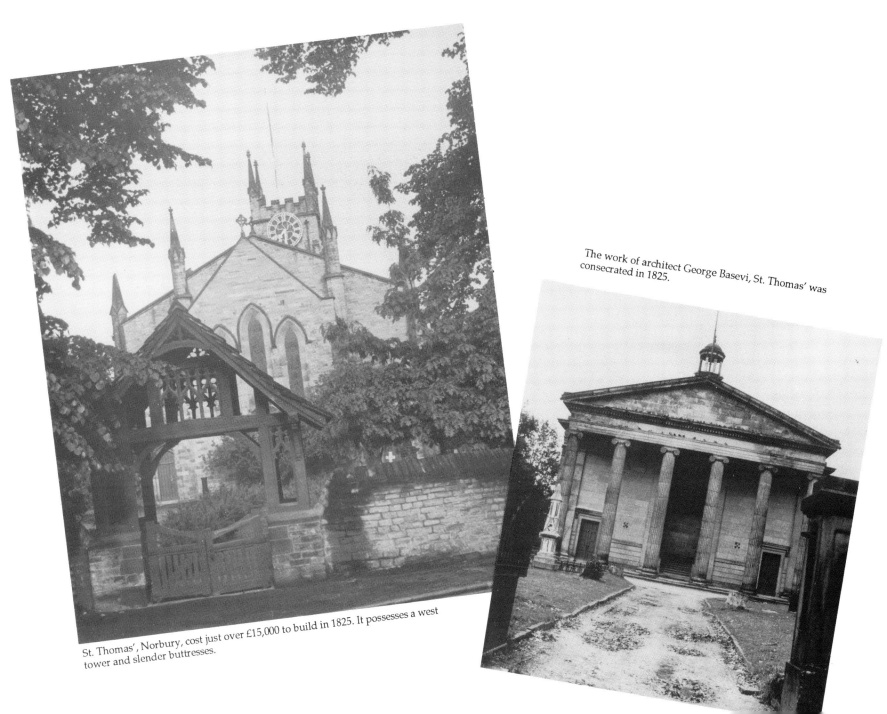

The work of architect George Basevi, St. Thomas' was consecrated in 1825.

St. Thomas', Norbury, cost just over £15,000 to build in 1825. It possesses a west tower and slender buttresses.

Schools

Sunday Schools

Sunday Schools played a major rôle in the education of Stockport children, with perhaps the Stockport Sunday School being the most important of these establishment. Built by subscriptions in 1805, it had over 4,100 scholars on the books in the 1820s. Designed to provide religious instruction for the 'labouring poor', it was run by 'gratuitous teachers' who taught their children in a four-storey building which was 132 feet long and 57 feet wide.

Other examples of Sunday Schools appeared in Edward Street, High Street and Church Street, while those of the Wesleyan persuasion attended Sunday Schools in Heaton Lane and Mount Tabor. The influence of these places of learning may be appreciated when it is realised that in 1825 some 12,000 children received instruction in Stockport's Sunday Schools.

Other Schools and Colleges

Stockport contains some famous schools which include Cheadle Hulme School (1855), Stockport School and the Grammar School. There are some 20 Secondary Schools in the borough together with under 5's playgroups, and a large choice of Nursery, Infant and Primary Schools. Post-16 education is offered in the College of Technology or Sixth Form Colleges.

In order to give further insight into post 11+ education, two schools and one college will be described - the Grammar School, Stockport College and Mile End School.

Stockport Grammar School

Founded by Sir Edmond Shaa in 1487, Stockport Grammar School has played a prominent part in the town's development for centuries.

Shaa was a local man who became Lord Mayor of London, Prime Warden of the Goldsmith's Company, and Court Jeweller to Edward IV, Richard III and Henry VII. Details of Edmond's early life are not known but his parents hailed from Dukinfield which was a hamlet in the parish of St. Mary, Stockport. He decreed that a chantry priest would be directed to *'kepe a gram scole contynually in the said town of Stopforde'*.

So, one of Britain's most ancient schools probably held its first lessons in the Davenport Chapel at St. Mary's Parish Church, Stockport. The first recorded Master of the School was John Randall who had to 'teach the science of grammar'. In the 15th and 16th centuries 'grammar' meant Latin grammar.

By 1608 the School occupied a site in Chestergate where today one finds the frontage of the Merseyway Precinct. Towards the end of the 17th century the curriculum had been altered to include Greek and Hebrew in addition to Latin. The early 1700s was the most successful era of the school's activity since its inception. Much of the credit may be attributed to the master, Joseph Dale whose work soon attracted pupils from outside Stockport, and gradually boarders were accommodated from Lancashire and Derbyshire. Between 1717 and 1734 Dale sent 19 of his pupils to St. John's College, Cambridge and two others to Trinity.

In 1792 a new master was appointed, the Reverend Elkanah Hoyle who is best remembered for admitting girls and introducing fees. In the 1820s it was decided to relocate Stockport Grammar School which had remained on the same site since 1607. Wellington Road had recently been built and a new turnpike road to Cheadle was being constructed. The school was built where the turnpike (today's Greek Street) left Wellington Road (the site of the present Art Gallery), and the foundation stone was laid in 1825. The one full-time master was given a salary of £65 and boys used the lower classroom, with girls housed in the upper room.

The school's fees in the 1850s were two guineas a year in the Upper School, while the Lower School still offered free education.

A School's Inquiry Commission set up by Parliament in 1864 visited the premises and published its findings three years later. At this time some seven teachers provided a classical education for 130 Upper School pupils and a commercial education for those in the Lower School.

By 1910 the 155 pupils on roll prompted the Board of Education to suggest there was serious overcrowding, and since the Greek Street site precluded further expansion, a new location was required. Following consideration of several sites, the place chosen was the Mile End Hall estate with the proximity of Davenport's LNWR Station playing an important part in the final decision.

The move to Buxton Road took place during the 1915 Christmas holidays, and in 1916 new buildings were designed for 250 pupils in 10 classrooms grouped in a two-storey block. The School's first Sixth Form began at the close of World War One, while new playing fields in front of the school came into use during 1923.

Stockport Grammar School was founded in 1487, by Sir Edmond Shaa, Lord Mayor of London.

There were almost 400 boys on roll in the mid-1930s, and, of course, celebrations in 1937 marked the 450th anniversary of the founding of the school.

War was looming on the horizon and that meant gas masks were carried at all times, afternoon sessions finished at 3.30pm, and homework and Saturday morning school were cancelled. As teachers were called up to serve their country they were replaced by lady members of staff, and senior pupils carried out ARP duties in the locality. Older residents will remember that bombs fell on Davenport Park in the vicinity of the school.

Following the hostilities life returned to normal and Mr. Philpot was appointed Headmaster in 1941, staying in the post until 1962.

A new science block came into use in use in 1957 and three years later there were 454 pupils in the Senior School (including 105 in the 6th Form) and 158 children in the Junior School. Following Mr. Philpot's retirement, Mr Willoughby Scott assumed the post of Headmaster at a time when extensions and refurbishment included new accommodation for the Lower Sixth. The 1974 election of a Labour Government committed to the concept of comprehensive education threatened the school's direct grant status, and so it reverted to an independent school in 1976.

Mr. Scott retired in 1979, and from among the 130 candidates who had applied, Mr. Hugh Raymond Wright was selected as Headmaster. The development of Stockport Grammar School was accelerated by the acquisition of the site of the adjacent Convent Girls' High School in 1980. It was in this year that girls were admitted to the Grammar School again, and five years later there were 576 boys and 388 girls in the Senior School. Since 1980 the buildings on the Woodsmoor Lane side of the site have been altered and new squash courts have been built alongside the swimming pool. On July 5th, 1984 the Lord Lieutenant of Greater Manchester, Sir William Downward, formally opened the eight Modern Language rooms which include two full-sized language laboratories.

In 1985 Mr. Wright, who left to take up an appointment as Headmaster of a Norfolk grammar school, was succeeded by Mr. D.R.J. Bird, M.A. His arrival in Stockport coincided with a record number of 69 entrants to university and 18 to polytechnics and colleges of higher education.

1986 saw the Mayor of Stockport open a major extension to the Junior School to improve the teaching and learning facilities for art, music and computing. 1987 was the quincentenary year of Stockport Grammar School, and Her Royal Highness, the Princess Royal, visited the school and unveiled a plaque to mark the event. The Lord Mayor of London received the Headmaster and Mrs. Bird at the Mansion House, London, in June 1987. The Lord Mayor accepted a volume of the history of Stockport Grammar School to commemorate the founder, Sir Edmond Shaa, who was the 200th Lord Mayor of London (1482-83).

At the beginning of the Spring term, 1989, the school began to use the new dining hall which had been built on the Davenport Theatre side of the school. For the first time since 1916 the buildings of Stockport Grammar are visible from the A6 road. The Governors planned further additions to link the Dining Hall with the 1916 Hallam building around a second quadrangle; these included a craft design centre and new teaching rooms. In 1993, work was completed on the impressive entrance to the school on the A6 road.

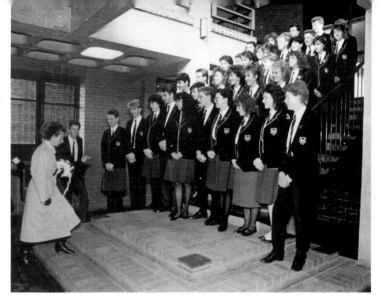

Princess Anne (as she was at the time) meets the Prefects of Stockport Grammar School in February 1987 during the Quincentenary celebrations.

Stockport College

The idea to establish a technical school in Stockport was first mooted in 1886. It was opened three years later by Sir John Lubbock, the foundation stone having been laid in 1888 by the Lord Mayor of London.

The principle aims were to train students for jobs in commerce and industry. Increasing numbers led to expansion with a new wing added in 1915. Today Stockport College is one of the largest further education establishments in the country with some 11,000 students on full-time, day release, part-time and evening courses. The eight departments are able to provide more than 150 courses at all levels from GCSE to post graduate. In 1987 the College was designated a 'Centre of Excellence' for engineering by the Department of Trade and Industry. More recently, the centenary celebrations have allowed students and locals to examine the development of this major learning institution.

Mile End School (Stockport School)

Situated at Mile End, this school was 50 years old in September 1988, the occasion being marked with social and cultural events. The anniversary on September 8th is significant for another reason. On that day, a century ago, the Lord Mayor of London laid the foundation of the Technical School in Greek Street. This was the present school's forerunner, with 1938 bringing the transfer of the school to the new buildings at Mile End which then accommodated 670 boys. Examples of famous pupils are actor Peter Barkworth, ex-Manchester United soccer star Alan Gowling, and first class cricket umpire Barry Doddlestone.

5. Commerce and Industry

Shopping

It is clear that by the end of the Anglo-Saxon period a market village existed in the area. By the 12th century, some considerable time before the granting of the first Charter, the main features of the market area had been developed.

The Charter of the Freedom of Stockport was granted in 1220 and 40 years later the town was given permission to hold a weekly market and an annual fair.

The borough today possesses numerous facilities, including the Merseyway Precinct with its traffic-free malls and overhead parking. Parallel to the Precinct one finds Prince's Street, while the open and covered markets draw the crowds from Stockport and surrounding areas.

Some fascinating shops are to be found near the market, on Lower Hillgate and the Underbanks, while Stockport Village is well worth a visit. This is a collection of craft shops close to Mersey Square providing a wide range of handmade items.

Of course, in addition to town centre shopping, retailers are found in over 20 precincts and shopping parades which prove popular with people throughout the borough.

Industry

Stockport was a focal point for the textile industry in the 16th and 17th centuries when weaving and spinning often took place in the home.

The upsurge of factory development was encouraged by the silk industry and the Tin Brook area in the Carr Valley serves as an example of Stockport's first industrial location. Here in the mid-18th century silk mills like Lower Carr Mill could be found, powered by water from the Tin Brook while the first silk mill was established on the Carrs in 1744.

Stockport had one silk throwing mill in operation in 1732 and 10 years later there were a dozen mills employing some 2,000 workers. However, by the 1700s silk declined in popularity as cotton made its mark on the commercial scene.

The town's rivers encouraged the growth of industry and most mills stood near rivers from which they received water power. This was assisted by ventures like the High Carr dam (1745) which controlled the waters of Tin Brook.

The steam engine came to the town in 1789 and this led to the gradual demise of water-driven mills. In fact, by 1830 nearly all stages in cotton manufacture were steam-power-driven as the age of steam made its impact on Stockport. During the early 1900s there was a decline in the number of cotton mills, and today many are used as multiple occupancies.

There has been a considerable shift of emphasis on Stockport's industrial character since the 1950s - the textile industry has lost its dominance and the town now possesses a broad base of commerce and industry.

The borough contains a highly skilled workforce of almost 144,000 people, most of whom find work in the service sector. An above average percentage of those in employment are professional people, managers and clerical workers.

Stockport's varied portfolio of industry takes in many large national and international companies. These include Philips Semiconductors, BASF, Shell, AA, Hewlett Packard, RAC, British Aerospace and Simon Engineering. The last two companies will be considered in some detail in this chapter.

Some Examples of Mills

There are no tangible remains of Stockport's early silk mills, many of which were converted to cotton spinning before the close of the 18th century. To obtain a glimpse of the town's first industrial area, proceed down Waterloo Road from Middle Hillgate and look out for Tin Brook which runs through the so-called Carr Valley. Stockport still possesses reminders of the spinning and weaving days in the form of its many mills, some of which are now considered in alphabetical order.

Broadstone Mill

This Reddish mill was built alongside the Ashton Canal. The Broadstone Spinning Company constructed two large mills in 1903-7 for 260,000 mule spindles, boilers, engines, plant and machinery. Power was supplied by two Saxon triple-expansion engines, and in 1919 the mills were bought by the Broadstone Mills Limited. They closed in 1959, but the mills are still easily recognisable by the ornamental water tower and dome.

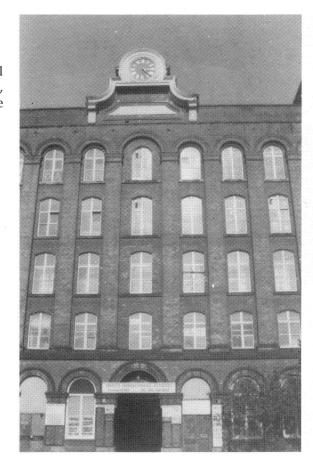

Houldsworth's mill is still a local landmark a century and a quarter after construction of the four-storey building.

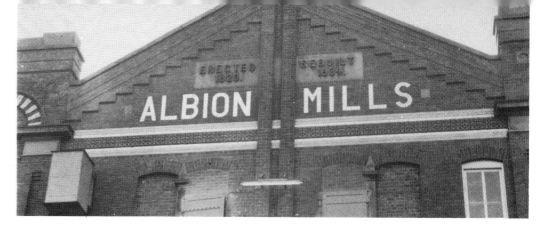

Enlarged in 1858, the Albion Flour Mill was destroyed by fire in April 1893.

Houldsworth's Reddish Mills

Henry Houldsworth built the Reddish Mills between 1863 and 1865. Positioned alongside the Ashton Canal, the Houldsworth Mill comprises two four-storey buildings linked by a central five-storey unit. This is surmounted by a clock and bell tower, whilst the huge octagonal chimney dominates this area of Reddish.

Houldsworth's name should not be associated only with the mill. Sir William Houldsworth gave his name to Houldsworth Working Men's Club and Houldsworth School. St. Elisabeth's Church, Reddish was also built by Sir William and consecrated in 1883 (see Chapter Four).

The mill became the focus of community life with many local people working in the cotton industry until its closure in 1958. The place did not fall into disrepair, however, and during the 1980s Houldsworth Mill became an important centre for a mail-order firm and several small businesses. Even though cotton is no longer a major factor in the lives of Reddish people, Houldsworth's name is perpetuated by his buildings and a public clock in the Reddish square which bears his name.

Pear New Mills

Deriving its name from the pear-shaped dome at the top of the water tower, this five-storey building was completed in 1913. The mill features a separate engine house and the premises are located on the north bank of the River Goyt near Woodbank Park. Interestingly, the structure is only half of a proposed larger mill. The second section was never constructed because the original company had been liquidated in January 1912 and the buyers, the Pear New Mill Company, in the end, could not afford it or the proposed housing estate for workers on adjacent land. It was the last Stockport mill built by a Stockport Limited company to close, which it did in 1978 when the then owners, Viyella, moved spinning to Atherton.

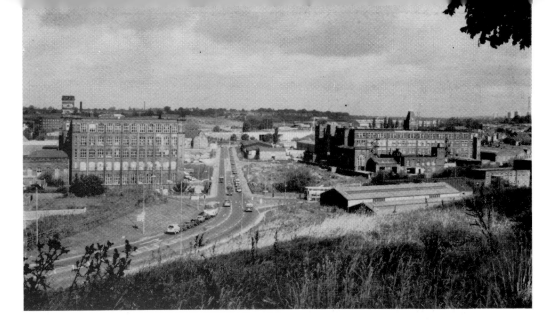

Mills in the Portwood area once received power from the River Tame.

Portwood Mills

Commuters using the Tiviot Way on their journey south may have glanced to the right where a number of interesting buildings are bounded by Marsland Street, Brewery Street and Water Street.

Here one finds Marsland Street Mill and several more on Water Street. The River Tame proved most valuable as a source of water power and in fact a water wheel was still in use in this district until 1834.

Portwood Mill dates from 1833 and was for many years owned by the Howard family, before going to the Portwood Spinning Company which had over 100,000 spindles in the late 1800s and early 1900s.

Meadow Mill, Water Street, built in 1882 for T. and J. Leigh was used both for cotton and wool spinning. The engine house occupied the centre of this six-storey mill whose distinctive principal building overlooks barren wasteland today.

Wellington Mill

Situated just south of Daw Bank on the west side of Wellington Road, this building was constructed in 1830-31. An example of one of Stockport's oldest complete mills, the seven-storey structure features a full circular chimney. Starting its days as a cotton mill, the place eventually went over to the manufacture of hats and became the home of Ward's Hat Company.

Opposite:
In 1910, Alliott Verdon Roe formed a company which bore his name. Today, as the Manchester of Avro International Aerospace, it continues the great traditions which he established.

Other Industries

Stockport was associated with hat making as far back as the 1500s when cottage industries produced felt from rabbit fur and wool. By the 1830s there were some 20 hat manufacturers in Underbank, the Hillgate area and Edgeley. Towards the close of the 19th century a dozen hat making factories existed including Carrington's, Ward's and Battersby's, whose water tower in Offerton has acted as a local landmark since 1886.

Work began on Lee's Hatworks near Higher Hillgate in 1870. Hillgate is the home of the Associated British Hat Manufacturers. Their offices are today based in a house formerly occupied by Samuel Oldknow, and the hatting business stands on the spot where William Radcliffe's and Samuel Oldknow's cotton mill was founded. It is interesting to note that in the Higher Hillgate mill Oldknow used the first steam engine in Stockport for turning his winding machines used in the production of muslin. The mill was burnt down, to be replaced in 1893 by a three-storey building which is in evidence today.

Hats are still produced at the Associated British Hat Manufacturers and felt hats are a popular commodity.

Corn Mills

Corn milling was a flourishing local industry, the Nelstrop Mill serving as a good example of a company engaged in this business. One William Beard owned Albion Mill near the canal at the top of Lancashire Hill and it was later acquired by William Nelstrop. He also had considerable interest in the Park Corn Mills, since he had married the daughter of William Oakfield who ran the company. Today's Nelstrop Mill is a four-storey structure dating from 1894.

Other examples of corn mills include Bowers' in Egerton Street and a steam corn mill constructed in 1830 on Hempshaw Lane.

Stockport boasted several tanneries and rope works, some of which manufactured cotton ropes for mill engines. Examples were the Lancashire Hill Ropery (next to the Ashton Canal near Manchester Road), and Turncroft Lane Ropery (built in 1844 and closing in 1930). Tanning was a popular 18th century industry with factories found in several places, including Canal Street and Swallow Street.

Of course, textile finishing industries flourished where there was a reasonable water supply. An example found alongside the Mersey is Park Bleachworks, while Reddish Vale Printworks was located next to the River Tame. This firm commenced operations in the late 1700s and specialised in calico printing. The brewing industry is described in Chapter Seven.

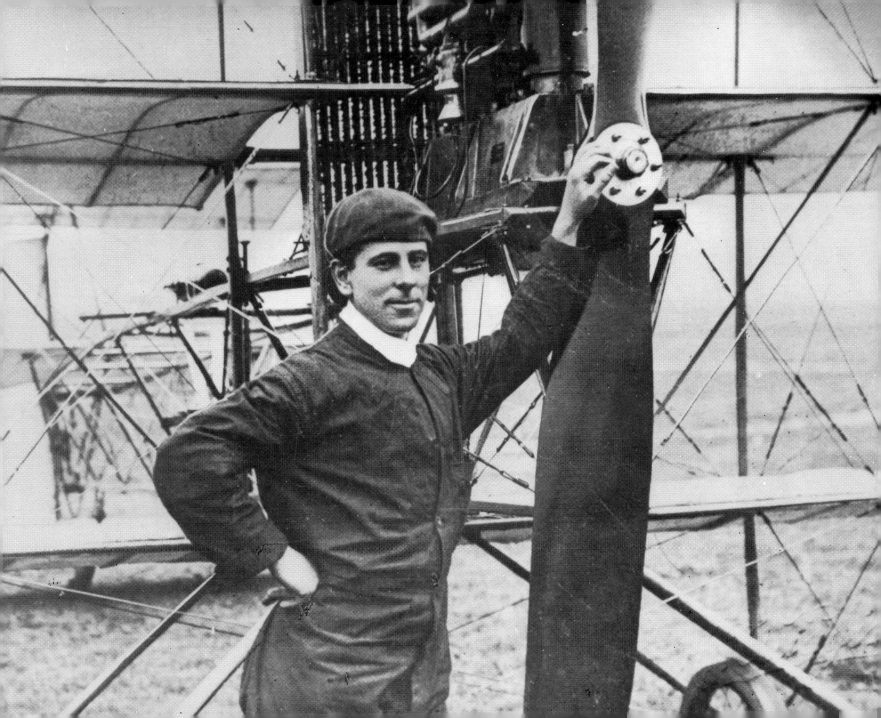

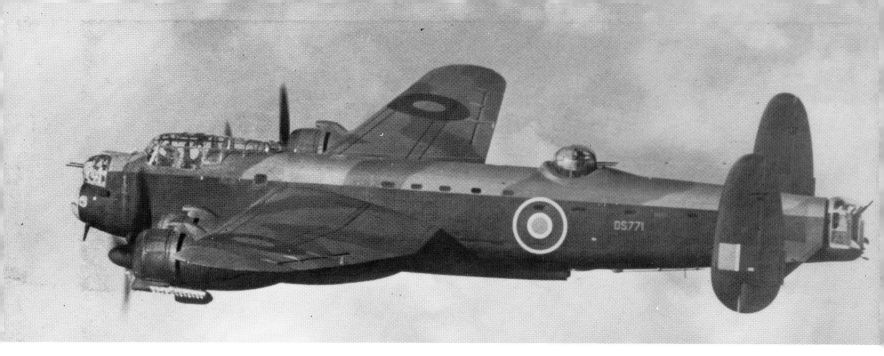

The Lancaster in full flight. Of the 7,377 Lancasters built, 3,670 were assembled at Woodford.

Modern Industry

Avro International Aerospace (formerly British Aerospace, Woodford)

Avro International Aerospace is expected to play a prominent rôle in 21st century aviation. The late 1980s brought the Advanced Turbo Prop (ATP) on the market with the company announcing it as the most fuel-efficient commercial airliner in the world. It is likely that the future job security of the 6,500 workforce at the British Aerospace's twin factories at Chadderton and Woodford depended on the success of the ATP. The auguries for the 1990s look good, especially as the company invested £16m in both plants in the late 1980s. So how did all this begin at Woodford?

In 1908 Alliot Verdon Roe managed to fly his flimsy biplane for 150 yards. He was entered in the history books as the first Englishman to fly, and 1910 A.V. Roe formed a company in Manchester which bore his name. In 1912 the world's first totally enclosed monoplane carried the name of Avro and larger premises were acquired in Miles Platting, Manchester. The Avro 500 aircraft set a fashion in biplane design which was to last until the rebirth of the monoplane in the mid-1930s.

48

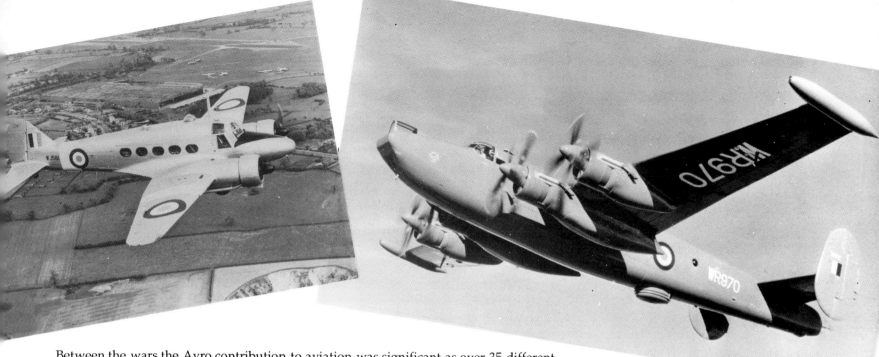

Between the wars the Avro contribution to aviation was significant as over 35 different types were produced. Some examples of these aircraft were Type 536, Type 547 Triplane and Type 555 Bison, designed in 1921 as a fleet gunnery spotter and torpedo layer. Type 652 Anson was a popular model, the first one flying in January 1935. In fact during 17 years of continuous production, 11,020 Ansons were built.

Expansion of the company necessitated acquiring premises in Failsworth and the 'aerodrome' at Woodford in 1925. The factory at Woodford was enlarged in 1939, giving A.V. Roe the production capability to mass produce the Lancaster Bomber during World War Two. At peak production, Lancasters were coming off the line at a rate of 47 per week.

The Manchester and Stockport factories produced over 8,500 Avro 504 trainers and some 7,500 Lancaster bombers. In fact Avro Lancasters delivered two thirds of the total tonnage of bombs dropped by the RAF from the beginning of 1942.

Following the War several Lancasters proved their worth as aircraft with Coastal Command, but it became clear that there was a requirement for a larger maritime patrol aeroplane. This led to the production of the Shackleton, the first deliveries to Coastal Command beginning in Spring 1951. The Shackleton continued in use until the early 1970s when the Nimrod assumed its reconnaissance rôles.

Left:
A type 652 Anson flying over Woodford. The road to the right leads to Wilmslow. The aircraft shown was the last Anson, going into service with the RAF in May 1952.

Right:
This prototype Shackleton MR3 WR970 first flew on September 2nd, 1955. It had a redesigned nose and much smoother outline than the MR1.

On August 30th, 1952 the Avro 698 made its first flight and it was subsequently given the name 'Vulcan'. This aircraft became firmly established as the backbone of RAF Strike Command, but as multi-rôle Tornado aircraft made their début, the Vulcans were pulled out of service. By 1963 the name of Avro had been absorbed into Hawker Siddeley Aviation.

Chadderton and Woodford have contributed a great deal to aviation. They produced the world's first four-engined transport, the Tudor 8, as well as the first delta-wing bomber - the Vulcan. They can also be credited with the Nimrod, a versatile jet-powered maritime reconnaissance aircraft.

Avro International Aerospace Today

Woodford lies in countryside to the south of Stockport, employing some 3,000 people on marketing, design, research, final assembling and flight testing. The assembly area and associated offices cover over one million square feet of floor space. There is a separate large flight test facility which is also used to prepare aircraft before final delivery.

As well as the assembly and flight testing of current products such as the 748, ATP and 146, Woodford was the leading site for the design, production and support of large military aircraft. The factory was also involved in major servicing contracts of aircraft, including refitting Nimrod aircraft and the Buccaneer project.

The Overhaul and Test Complex is a self-contained building at Woodford where there are two main work areas - the detail fitting workshop and the calibration laboratory. The factory also accommodates a trimming department, electrical production unit, sheet metal department, paint spraying facilities and, of course, a comprehensive technical support organisation.

Woodford production is supported by extensive manufacturing facilities at Chadderton, some 16 miles away. The Woodford airfield is capable of accommodating all aircraft currently operated by the RAF and large civil aircraft since the main east-west runway is 7500 feet (2286 metres) long by 150 feet (45.72 metres) wide.

Avro International Aerospace is a new company which was being formed in the early 1990s by British Aerospace and Taiwan Aerospace Corporation. It is dedicated exclusively to the design and production of regional jet aircraft, the RJ70, RJ85, RJ100 and RJ115. With marketing centres in Taiwan at Taipei, Washington in the U.S.A., and the company headquarters at Woodford, Avro International Aerospace will be the first true international aircraft manufacturing company.

Simon Engineering

Industry in Stockport is synonymous with Simon Engineering, an international group of companies supplying process plants, machinery and technical services to industries and utilities throughout the world. The Group's operations fall into three divisions - manufacturing, engineering contracting and services. Head office of the Group is on Bird Hall Lane, Cheadle Heath, Stockport. So how did this large company begin and who founded it?

The wide diversity of interests has grown from the two original companies established between 1878 and 1880 to sell two products - flour milling machinery and by-product coke-ovens. Their founder was a young Silesian engineer named Henry Simon who, at the age of 25 years, came to Manchester as a refugee from Prussian oppression.

His business acumen, mental ability and diploma in engineering from Zurich Polytechnic, Switzerland, more than compensated for Simon's lack of friends and finance. He had arrived in a strange country without influence or cash but soon he established himself as a consulting engineer with an office in Manchester.

In 1878 he signed a contract to supply the first flour rollermill plant in Great Britain to McDougall Brothers, Manchester. This order signified the founding of the Simon Group.

By 1892 Henry Simon was able to announce he had built more than 400 mills on his system throughout the world.

How many Stockport people wonder what is behind the name Simon-Carves? Well, Henry Simon teamed up with the famous French coke-oven engineer, François Carvés to pioneer the by-product coke-oven. The partnership led to the establishment of Simon-Carves in 1880, later to become the leading British firm in by-product coke-ovens.

The Simon SS 600 Super Snorkel is the highest Hydraulic Platform in the UK with a 60 metre upreach. On his visit to the Simon factory in Dudley, the Author tried out the machine, which was lifted to its highest elevation.

51

From the early years of this century and under the direction of Henry Simon's son, Ernst (later created Lord Simon of Wythenshawe for his work in helping to build that garden city), the two companies flourished.

A coal washeries department was established in 1902 and during World War One a chemical plant department was formed. Of course, the milling business of Henry Simon Ltd was expanding, necessitating the creation of a materials handling department in 1911. This was followed by the centralisation of the Simon offices and works at Cheadle Heath in the 1920s.

By the late 1950s Henry Simon Ltd and Simon-Carves Ltd had created or acquired numerous subsidiary companies and developed extensive activities in the UK and abroad. The two companies were merged in 1960 to form a holding company, Simon Engineering Ltd, but they retained their names and continued to trade in their respective businesses. In the mid-1960s a major reorganisation occurred and the diverse businesses and subsidiaries of the two founding companies were organised into autonomous operating groups.

In 1982 the holding company became Simon Engineering plc in keeping with the 1980 Companies Act.

Today subsidiary and related companies are organised into three divisions which identify Simon's three strategic business sectors of manufacturing, engineering contracting and services. The coke-oven business was sold in the 1970s and the milling machinery activity in 1988.

Simon is now an international organisation serving important industries and utilities all over the world. It employs some 10,000 people and its sound financial base ensures it is well equipped for a second century of business.

In addition to accommodating Simon Engineering's head office, Stockport also plays host to Simon-Carves at Cheadle Hulme, from where projects for chemical, nuclear, industrial and food processing plants are managed. Machinery for the corrugated box industry is made at Cheadle Heath and systems are developed there for the ground control of aircraft at airports.

The name Simon is also found on hydraulic access platforms and fire-fighting appliances which are manufactured at other Simon factories for use throughout the world.

All this is a far cry from 1880 when the young refugee arrived in the north west and founded what is now a dynamic and prosperous company.

6. Transport and Public Services

Horse-drawn Vehicles and Trams

Horse-drawn coaches had been in service for many years with the Turnpike Act introducing a regular coach route via Stockport to Buxton in 1724. Interestingly, the A6 is the oldest turnpike road in the north west and by 1754 a road was running from Manchester to London, stopping at Stockport on its four-and-a-half day journey. Toll gates could be found at a number of places, including the main road through Bullock Smithy (Hazel Grove) where gates were positioned at Bramhall Moor Lane and the top of High Lane. Of course, the coaching business encouraged the rise in development of such coaching inns as the 'Royal Oak', 'White Lion' and 'Warren Bulkeley'.

The introduction in 1830 of a horse-bus service between Manchester and the 'Warren Bulkeley' heralded the first stage in public transport for Stockport. In 1874 a further service ran from this pub to Hazel Grove.

Regular routes were well under way by the mid-1800s and in 1860 11 double-decker 42-seater omnibuses plied the Manchester - Cheadle route. A service also commenced operations in 1874 when small wagons ran from Hazel Grove to Stockport, leaving the 'Bull's Head' every two hours. An enterprising Mr. Dunn started a horse-drawn bus service from the 'Red Lion', Hazel Grove to Stockport, and passengers could choose from seven trips a day.

Following the passing of the 1870 Tramways Act Manchester Corporation built and leased tramways in their area. So, in 1878, Stockport Corporation constructed a line from the town connecting with the Manchester tramways. May 1880 saw the inauguration of a horse-drawn tram service into Stockport.

Later on, the Stockport and Hazel Grove carriage and Tramway Company promoted the authorisation from Parliament to build a line connecting St. Peter's Square with Hazel Grove. This carried its first passengers in 1889. Ten years later a committee set up by the Corporation examined the viability of electrifying existing tramways. As a consequence of this the first section to be electrified was between Mersey Square and Tiviot Dale.

A new route to Woodley came into existence in 1901 via Vernon Park and Bredbury, and this was followed by trams running to Sandy Lane and Reddish.

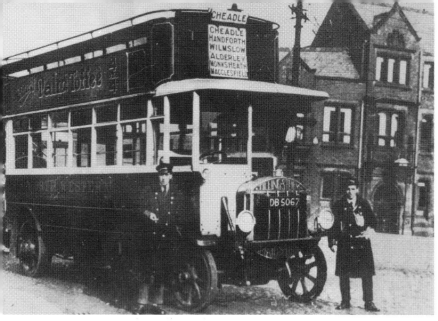

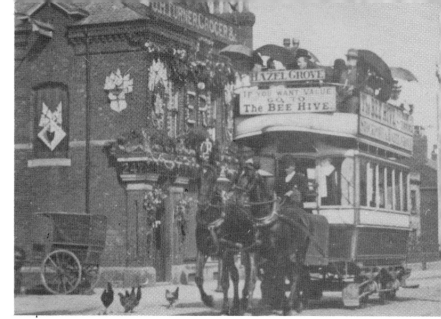

The crew of this North Western Tilling Stevens bus stops for a break on the Macclesfield-Cheadle route. Thomas Tilling was one of the first fleet owners in London to employ motor buses in 1904, and he joined forces with Mr. Stevens in 1911.

Top right:
This open-top vehicle belonged to the Stockport and Hazel Grove Tramway Company. The advertisement on the front encourages shoppers to spend money at the 'Bee Hive'.

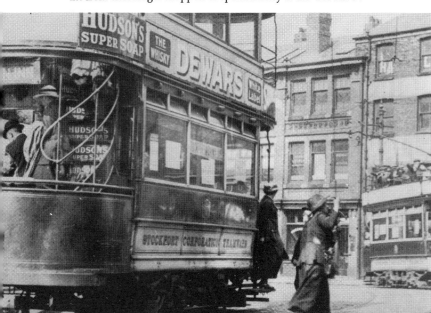

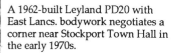

A busy scene in Petersgate 1916 as passengers alight from an electric tram whose 'clippie' is seen in full uniform. The Stockport Corporation Tramways vehicle displays advertisements for Dewar's whisky and Hudson's soap.

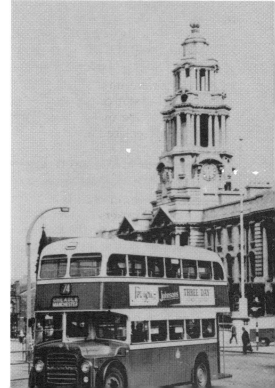

A 1962-built Leyland PD20 with East Lancs. bodywork negotiates a corner near Stockport Town Hall in the early 1970s.

Manchester Corporation updated the horse tramway between the city and Stockport and electric traction began in June 1902, with Stockport financing the work in its area. Three years later electric trams ran on the Hazel Grove - Stockport route. It was about this period that roofs were fitted to Stockport trams while interior refurbishment included the introduction of upholstered seats.

Time was running out for trams as the Gatley service was reduced in length during 1931 with trams only going as far as Cheadle Heath. Through routes to Hyde and Manchester were closed in 1947 and 1949 while 1951 brought the end of the Edgeley and Vernon Park services.

Stockport's last tram ran on August 25th, 1951. The illuminated vehicle marked the final closure of the tramways which had played such an important part in the life of the town.

Buses

The first motor buses were put on Stockport's roads by a Mr. Clayton in 1908, the Swiss built buses operating on a route between Stockport and Marple. In 1913 the Corporation introduced a trolleybus system to Offerton powered by the Bremen method of current pick-up. These Daimler vehicles carried Brush single-decker bodies, and the three trolleybuses were unusual at the time in that they relied on foot-operated controls as opposed to the more conventional hand controls.

World War One meant that obtaining spares was a problem, and so AEC petrol engined buses replaced the trolleybuses whose last journeys were made in 1920.

In 1923 a bus route began operating between Heaton Mersey and Reddish. Gradually more bus routes were provided in Stockport with 1934 marking the launch of the Corporation's first double-decker buses.

Stockport's fleet in post-war years comprised a variety of makes, including Leyland PD2/1 double-deckers; Leyland PD2A/East Lancs. vehicles; Crossleys, and Leyland PD3s with East Lancs. bodies.

North Western Road Car Company

Any reference to public transport in Stockport must contain information on the North Western Road Car Company whose headquarters were located in the town for many years, and whose operations were well known to the Author.

In 1913 the British Electric Traction Company developed several routes in the north west of England. In fact, attempts had been made to introduce regular services in the Macclesfield district the early 1900s, while a town service was operating in Buxton by 1920. Three years later North Western was incorporated and its offices were moved to Macclesfield.

Thomas Tilling Limited had a 50% controlling interest in the company until 1924. The head office was then transferred to Charles Street, Stockport. By this time, North Western buses were on the run in a variety of areas including Crewe, Matlock, Northwich, Ashbourne and Glossop.

In 1924 North Western and Ribble were instrumental in the construction of Lower Mosley Street bus station, Manchester. From here express services ran to such destinations as Newcastle-on-Tyne, London and Blackpool, while local routes included the 32 to Higher Poynton and numbers 27 and 28. These last two went to Buxton and Hayfield respectively, via Mersey Square, Stockport. Examples of North Western buses passing through the Square were Dennis Lolines, Leyland PD2/1s, or Daimler Fleetlines. Single-decker vehicles encompassed a variety of makes such as Leyland PSU C1/2 buses sporting Willowbrook bodies and Bristols with Weymann bodywork.

During the early 1940s, North Western passed from the Tilling Group to control by the British Automobile Traction Company. Change was in the air again when the 1968 Transport Act encouraged the establishment of the SELNEC PTE which took over the operations of a number of organisations including North Western and Stockport Corporation.

SELNEC, GMB and Deregulation

Few people will appreciate that plans were made as far back as 1931 to form a unified transport authority for the area now known as Greater Manchester. Stockport was one of the many authorities represented, but nothing came of the proposals.

A Government White Paper entitled 'Transport Policy' (July 1964) outlined some ideas for managers of Transport. These included the setting up of Conurbation Transport Authorities. The 1968 Transport Act made provision for establishing Passenger Transport Authorities and Executives with Stockport consequently becoming part of SELNEC (South East Lancashire, North East Cheshire). The town found itself in the southern division of SELNEC alongside the former Oldham, Ashton and SHMD undertakings.

Gradually the distinctive orange and white livery appeared on SELNEC buses where vehicles attached to the southern division sported the green SELNEC logo.

In 1974 the responsibilities for public transport were assumed by the Transportation Committee of the Greater Manchester Council, and the PTE became known as GMPTE.

Of course, the 1985 Transport Act introduced the deregulation of bus services outside London and so GM (Greater Manchester) Buses Ltd commenced trading on August 26th, 1986. Soon the 'Little Gem' minibus service was introduced, proving popular with passengers, and today some 400 of these vehicles serve Ashton-under-Lyne, Altrincham, Wythenshawe and Stockport.

Deregulation encouraged smaller operators to put their buses on Stockport's roads. One example was the Bee Line Bus Company whose 225-vehicle fleet covered many routes in and around Stockport. The brightly painted minibuses operated competitive services throughout south Manchester, and in particular the Stockport area.

Ribble took over the routes of Stockport-based Bee Line on September 26th, 1988. Naturally, a number of routes were altered, although the majority were retained. 1988 also brought the launch of the Bee Line Company's City Sprint minibus service linking Offerton with Manchester via the A6. In the 1990s a number of operators ply along the A6 including Bullock's of Cheadle.

Railways

Stockport received its first railway in 1840 when the Manchester and Birmingham Railway line passed over Stockport viaduct which was completed in 1840 (see Chapter Two). There was now a line from Manchester to Crewe via Stockport and Sandbach.

August 1842 heralded the opening of the Stockport to Liverpool railway via Cheadle, and the station was actually at Cheadle Hulme, just a few metres north along the line from today's Cheadle Hulme station. Quarterly tickets to Stockport were £2 first class and £1 second class.

A railway linking Cheadle Hulme to Poynton began business in 1845, and 12 years later the first train ran on a newly built railway from Stockport to Whaley Bridge. Comprising ten carriages this train departed from Edgeley Station in May 1857 and proceeded to Whaley Bridge via Hazel Grove, Disley and Thornsett (New Mills). Later on this route was extended to Buxton. Davenport on the Stockport - Buxton line was not initially designated a stopping place when the Stockport, Disley and Whaley Bridge opened in 1857, but following protestations from one of the local gentry, William Davenport, a small halt was built in 1858. It closed a year later owing to little traffic and re-opened in 1862.

2nd - SINGLE SINGLE - 2nd

Romiley To

Romiley
Stockport
(Tiviot Dale)

STOCKPORT
(TIVIOT DALE)

(M) 1/2 Fare 1/2 (M)
For conditions see over For conditions see over

2nd - SINGLE SINGLE - 2nd

Chinley to

Chinley
Stockport
(Tiviot Dale)

STOCKPORT (TIVIOT DALE)

(M) 3/9 Fare 3/9 (M)
For conditions see over For conditions see over

Railway tickets from yesteryear when a single ticket from Romiley to Tiviot Dale was priced one shilling and two pennies. The one-way trip from Stockport to Chinley was three shillings and nine pennies.

Opposite:
Locomotive 45156 proudly set off from Stockport in 1968. It was the last steam train to leave the town and overhead gantries indicate that electrification had arrived.

Opposite:
The former Cheadle railway station of the Cheshire Lines Committee is now a public house. It ceased railway duties in 1964.

The Stockport - Woodley Railway began carrying passengers in January 1863 and two years afterwards the Tiviot Dale Bridge opened, connecting Portwood with Tiviot Dale Station. In 1866 the Stockport - Timperley Railway (Cheshire Lines) came on the scene. In fact, the Cheshire Lines centred on Tiviot Dale, so completing the east-west link. This station went into service during 1865 and closed in 1967, being demolished the following year.

A line commenced operations in 1866 from Edgeley Junction to Northenden Junction, and 1875 saw the introduction of a route from Bredbury Junction to Romiley. In May of the same year the Reddish Junction - Brinnington Junction was first used, while one of the earliest railways to reach Reddish had been the London and North Western. Its Stockport - Guide Bridge route went via Reddish.

Of course, it should be remembered that the 16-arch railway viaduct at Reddish Vale carried the former Great Central and Midland joint line across the vale. Opening in 1875, it was constructed by workers who were accommodated in the adjacent purpose built 'Nine Houses'.

The start of the 20th century introduced several developments in Stockport's railway network. In 1901, for instance, a direct line from New Mills through the Disley Tunnel, Hazel Grove and Cheadle Heath was opened.

During the 1920s, Edgeley Station was a stop on the main London and North Western Railway lines which connected the north and south of England. At this time nine stations could be found in Stockport at Edgeley; Heaton Norris; Tiviot Dale; Reddish (two); Cheadle Heath; Heaton Mersey; Heaton Chapel and Davenport.

This situation would not last for ever as impending threats of closure brought about the cessation of passenger traffic at several stations. These included Heaton Norris (1959), Heaton Mersey (1961) and Cheadle (1964). During 1967, Tiviot Dale and Cheadle Heath ceased passenger work, and it was in the following year that the last steam train left Stockport.

1960 had seen the inauguration of the Midland Pullman Service from Manchester to London via Cheadle Heath. It was quite a sight to observe the sleek train in its livery of blue and white draw away from Cheadle Heath at 9.04am and 9.07pm each day. The Pullman left Manchester at 8.50am and departed from London at 6.10pm. This service was withdrawn in 1973.

Stockport still features in the national rail network and London is only two-and-a-half hours away by fast Intercity trains which are quite different from the locomotives of the 1840s.

The sign outside today's 'Navigation' public house is a reminder of when it once stood near the Manchester, Ashton and Oldham Canal.

Canals and Rivers

Manchester, Ashton and Oldham Canal

The first Act for this waterway was passed in 1792, while a further Act of 1793 authorised a branch from Clayton through Openshaw and Reddish to Heaton Norris, with another branch to Denton.

1797 saw operations begin on the Stockport section. Almost five miles in length and without any locks, it was bought by the Manchester, Sheffield and Lincolnshire Railway in 1848. The canal carried its last commercial traffic in 1934.

Much of the waterway has been filled in and today it is hard to visualise the rôle played by this canal. However, in its heyday it was of value to several local industries including Sandy Lane Brewery, Broadstone Hall Mill, Reddish Mill, Heaton Norris Foundry and Nelstrop's Flour Mill. This stood at the end of the canal, close to the 'Navigation Inn' where one arm of the canal provided a means of access to coal wharves, while another served Wharf Street Cotton Mill together with a silk mill on the Old Road.

Peak Forest canal

Authorised by an Act of 1794, the canal ran from the Ashton Canal at Dukinfield to Chapel Milton, Chapel-en-le-Frith, with a branch at Whaley Bridge. One of the main reasons for the construction of this waterway was the conveyance of materials from limestone quarries at Dove Holes. The Peak Forest Canal had as its most influential shareholder, Samuel Oldknow, the Stockport-based textile manufacturer who owned mills at Mellor and Marple.

From its junction with the Ashton Canal the Peak Forest waterway proceeds through tunnels at Rosehill, Woodley and Hyde Bank. It is then carried almost 100 feet over the River Goyt by the Marple aqueduct to Marple locks. Here it joins the Macclesfield Canal and there are 16 narrow locks each with a rise of 13 feet.

The principal commodities carried on the Peak Forest Canal were burnt lime and stone. It was bought in 1846 by the Sheffield, Ashton-under-Lyne and Manchester Railway who also leased the Ashton and Macclesfield Canals. The tonnage carried in 1858 was just under 380,000 but this had dropped to 136,000 in 1905.

Today the Peak Forest Canal is favoured by pleasure cruiser owners who can enjoy magnificent views of Derbyshire and the area around Marple.

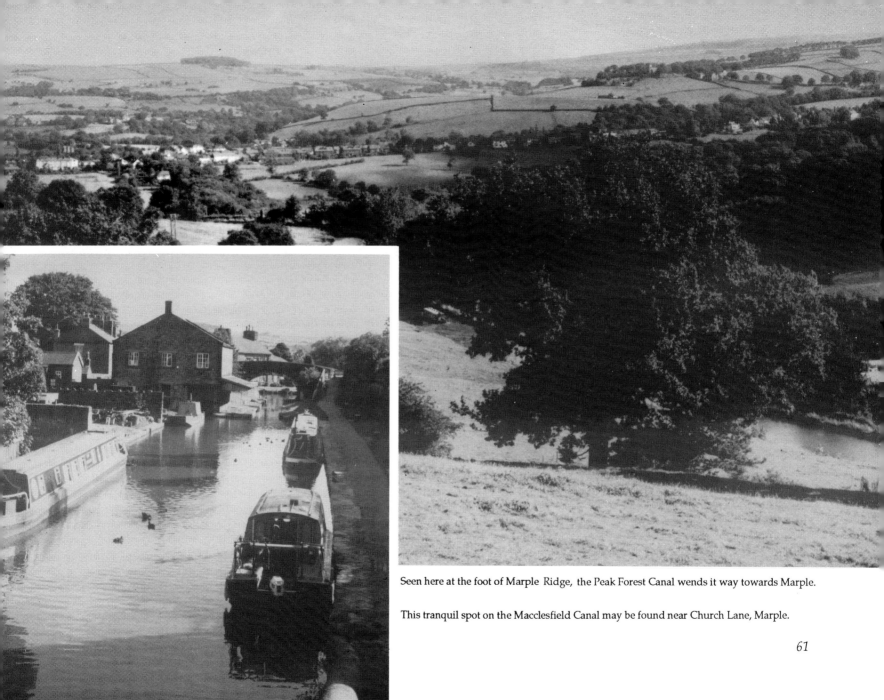

Seen here at the foot of Marple Ridge, the Peak Forest Canal wends it way towards Marple.

This tranquil spot on the Macclesfield Canal may be found near Church Lane, Marple.

Viewed here from King Street West, the River Mersey flows under the railway viaduct in Stockport's centre. Part of Wear Mills are found under the arches where the lighter colours indicate the widening process which was completed in 1889.

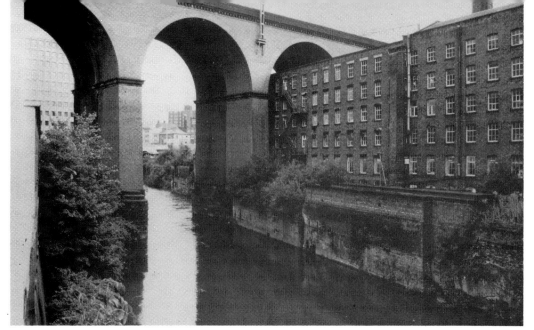

The River Mersey

Where does it begin and where does it go? It may surprise some people that the Mersey begins its life in Stockport and not in some distant Pennine hills. Three rivers combine to form the Mersey at Stockport - the Tame, Goyt and Etherow. The Goyt rises in the Derbyshire hills not far from the 'Cat and Fiddle Inn' and the Tame has its source near Denshaw, north east of Manchester. The Etherow can be traced to the Longendale Valley and, of course, it flows through Etherow Country Park.

The River Mersey was once the natural boundary between Cheshire and Lancashire. Stockport's origins are closely linked to it, the town growing up at a spot where sandstone hills gave easy access to both banks of the river.

Today it is hard to trace the Mersey through Stockport's town centre since it has been culverted to facilitate the construction of large shopping and commercial areas. In fact, Merseyway Precinct stands on large concrete stilts over the river. Talk of pollution has prompted authorities to look at River Mersey and during the mid-1980s the Department of the Environment published details of cleaning up the waterway.

But even if the Mersey does not arouse enthusiasm for a walk along its banks, the Etherow and Goyt rivers provide almost six miles of woodland walks. Who knows - maybe one day the Mersey will be the venue for idyllic waterside strolls through parts of Stockport's centre!

Public Services

The Police

The official Police Force was founded in 1826 and had its headquarters in Vernon Street. Prior to this townships had to levy a rate for paying constables. In Cheadle Moseley, in 1856, the rate was two pennies in the pound at a time when the custodians of the law in this district were a local police constable, a county officer and a special constable.

Stockport's Police Force was transferred to the Corporation in 1836 at a time when there was a lock-up on Melville Street near the Courthouse. Cheshire County Constabulary was founded in 1857 and operated outside the borough.

By 1904 the complement of Stockport's Police Force was 112 men, and constables received about 28 shillings a week. In the 1920s there were some 133 officers and men in Stockport where the headquarters were based in Warren Street. The police buildings were extended in 1961 at a cost of £15,000.

In 1974 some sections of Cheshire Constabulary and the Stockport borough police force were incorporated into Greater Manchester Police. Today's Stockport Divisional Headquarters is found on Lee Street with sub-stations at Bredbury, Cheadle Hulme, Cheadle, Hazel Grove and Marple.

The Fire Brigade

Early reports indicate that fire fighting in Stockport was undertaken with the help of a hard cart which transported a water carrier. The first steam fire engine was bought by Stockport Corporation in 1870 and this saw action in several fires in the late 19th and early 20th centuries. These included a blaze at Nelstrop's Mill, while on November 5th, 1902 the Vernon Mill was gutted by fire. It had been built in 1882 by the Vernon Cotton Spinning Company.

The Fire Brigade headquarters was found in Corporation Street before the Mersey Square premises came into operation on April 10th, 1902. This fire station was demolished in the mid-1960s to make way for the Merseyway development scheme. A new fire station replaced it at Whitehill.

Stockport possessed quite an impressive Fire Brigade in the 1920s when the fleet included motor and horse-drawn appliances, fire escapes and motor ambulances. At this time the Central Fire Station was connected with all parts of the town centre by a system of telephone alarm bells.

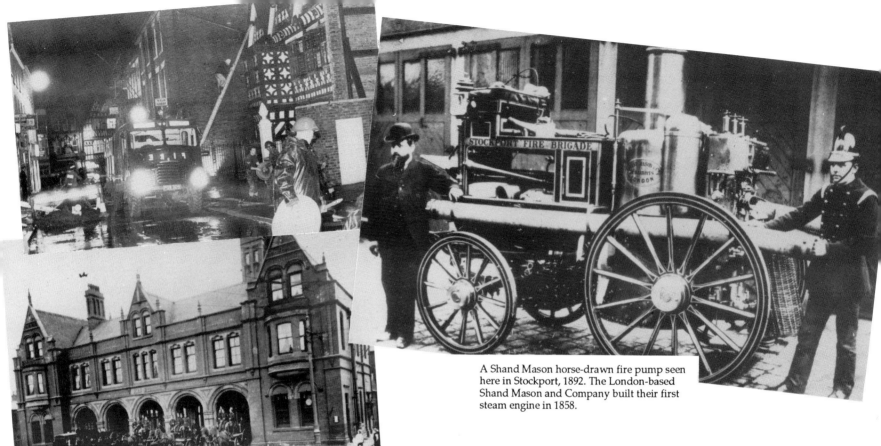

A Shand Mason horse-drawn fire pump seen here in Stockport, 1892. The London-based Shand Mason and Company built their first steam engine in 1858.

Mersey Square Fire Station became operational in 1902. Here, five horse-drawn appliances are ready to respond to any emergency.

Top left:
An interesting piece of drama from December 1977 during the national strike by firemen. Army personnel have arrived in a 'Green Goddess' fire vehicle to tackle a blaze at Nield and Hardy's, Great Underbank. A non-striking senior fire officer is climbing a ladder pitched against Underbank Hall.

In addition to the Mersey Square Fire Station Stockport had fire cover provided by smaller ones in the suburbs. For instance, there was one in Massey Street, Cheadle, until 1960 when the Turves Road Fire Station opened. This later went over to GMC Fire Service, having previously belonged to Cheshire Fire Brigade.

Another example of an outlying fire station was the one at Reddish. A delightful collection of public buildings were opened in 1908 containing the baths, library and fire station. These were in use for many years until the premises were altered with the former fire station now acting as a community centre.

Today's GMC Fire Service 'D' Division has its headquarters at Whitehill, Stockport. Other fire stations are located at King Street, Lisburne Lane, Cheadle and Marple. When necessary these are assisted by neighbouring Cheshire Fire Brigade stations such as those at Wilmslow and Poynton.

7. Breweries and Pubs

The media of 1830 spoke of excessive drinking and wanton drunkenness in Stockport following the introduction of the Beer Act in October of that year. The Government had introduced a new tax on malted grain and at the same time restricted the brewers' increasing monopoly on licensed premises. This meant that anyone could apply for a licence to sell ale (there were a number of illegal, unlicensed ale or beer houses in the area prior to this). Stockport beerhouses were not allowed to open their doors to the public before 4am and they had to close at 10pm.

Gradually the law regarding beerhouses was tightened up and in Queen Victoria's reign, pubs proper came into existence. Stockport is a haven for serious beer drinkers, although Robinson's is the sole surviving brewery in the town. Sadly, some pubs disappeared when Stockport's centre was redesigned, and places such as 'The Touchstone' and 'The Three Tuns' are no longer with us.

Left:
Demolished to make way for Debenham's, 'The Touchstone' was a cosy pub at the corner of Wellington Road North and Princes Street. At one stage it was owned by the Salford-based brewery, Watson and Woodhead.

Right:
'The George and Dragon', Heaton Chapel was a Clarke's public house before its acquisition by Boddington's.

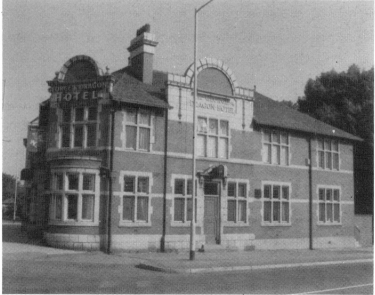

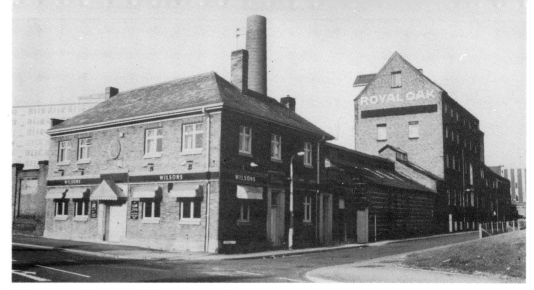

Royal Oak Brewery grew up around 'The Royal Oak Inn' on Higher Hillgate.

Examples of Breweries

Hempshaw Brook Brewery and Royal Oak Brewery are two companies whose names appear in large lettering on Stockport buildings. How often do passers-by wonder what these mean? Do they ask themselves if beer is still brewed here or how many breweries used to exist in the town? Here are some answers to these questions.

In the 1800s there were some 18 breweries in Stockport including the Windsor Castle; Ash; Eagle; Cotton Tree and the Waterloo Brewery. A few of yesterday's breweries will be considered along with Robinson's, the only one still in existence.

Bell's Hempshaw Brook Brewery

If you drink in the 'Adswood', 'Fingerpost', 'Rifle Volunteer' or the 'Tiviot Dale', then you frequent a former house owned by this brewery. These are just some examples of pubs belonging to a company whose beginnings go back to Hempshaw Lane in 1835. It was here that one Avery Fletcher bought land and started selling ale in 1836. Later on the brewery changed names as different people and companies became involved. Variously referred to as Smith and Bell, or Bell and Company, the business moved into new premises in 1930 where up-to-date facilities were provided.

During the late 1930s and early 1940s Richard Clarke's Reddish Brewery had expressed an interest in Bell's Brewery. However, it was Robinson's who gained control of the Bell and Company Limited, Hempshaw Brook Brewery in 1949. Part of the Bell's buildings continued in use for some years while under the auspices of Robinson's.

Clarke's Reddish Brewery

Aficionados of Boddington's beer will know that the Manchester-based business acquired Clarke's in 1963. If you take your tipple in the following pubs, then you are drinking in a former Clarke's outlet:- 'The Crown', Heaton Moor Road, 'The Gardeners Arms', Offerton; 'The George and Dragon', Manchester Road; 'The Ladybrook', Bramhall. Examples of Clarke's pubs outside Stockport would include 'The Elephant and Castle', or 'The White Lion', both in Macclesfield.

Actually, Richard Clarke hailed from Butley near Macclesfield and he worked at Stockport's 'Baker's Vaults' pub before taking over the nearby, 'Sun Inn' and then 'The Ash' in Reddish. Leaving this pub, Richard Clarke set up a small brewery in 1865, moving to larger premises in 1874. The business soon involved various members of the Clarke family and gradually Richard Clarke and Company Limited bought several public houses.

There was talk of merging with Bell's Brewery in the early 1940s but this came to nothing and some 20 years later Boddington's made an offer for the company. And so it was, a century or so after its inception, that Clarke's Brewery closed down in 1963 as Boddington's took over the company and its 60 houses.

Royal Oak Brewery

This grew up around the 'Royal Oak Inn' on Higher Hillgate where the licensee in the 1840s was producing beer at his own brewhouse. Following a devastating fire in 1875, new premises were sought and a former cotton mill was chosen for the business. Mineral waters were also manufactured in premises adjacent to the Hillgate brewery whose name is still visible today. The Manchester Brewery took over the business in the 1920s and it passed to Whitbread's in the early 1940s. Production ceased in 1957 when Whitbread stopped brewing on the premises. Some examples of Royal Oak Brewery outlets would be - 'The Ash', Manchester Road, 'The Comfortable Gill' (known as the 'Comfy' to locals); 'The Jolly Sailor'; 'The Navigation'; 'Railway Inn', Cheadle; 'The Unity', Wellington Road South, and the now demolished 'Warren Bulkeley' on Warren Street.

Pollard's Brewery

David Pollard owned a brew shop in Hillgate in 1969, later moving to premises on Buxton Road. His brewery occupied the defunct Reddish Vale Print Works where the distinctive 'Pollard's JB' was produced, a full-bodied, malty brew.

This elixir and Pollard's Best Mild found support from a number of quarters encouraging Mr. Pollard to acquire larger premises in Bredbury. Unfortunately beer from this enterprising brewery was not produced after 1982, one reason being the competition from larger breweries.

Robinson's Brewery

The Company

It was in 1988 that Robinson's celebrated 150 years of independent brewing, and today the ale is found in 360 Robinson houses. So how did Stockport's sole remaining brewery begin a century and a half ago?

Well, William Robinson was a weaver who had moved from Bollington to Stockport in 1837, and the following year he purchased a small inn on Lower Hillgate. It was called 'The Unicorn', and, of course, the mythical creature is still the trademark of Robinson's Brewery. The hostelry became a popular stop on the coach route to Manchester and when William's son, Frederic, took over the business he began to brew his own beer. Initially this was on sale in 'The Unicorn' but future developments led to his supplying the beverage to other licensed premises.

Frederic then purchased his first licensed house, 'The Railway' in Marple Bridge. Today this is better known as 'The Royal Scot' where drinkers partake of their tipple surrounded by pictures of Manchester City. By 1890 Robinson's owned a dozen licensed houses at a time when expansion to the brewhouse was essential in order to keep pace with orders.

During the 1920s the company acquired Schofield's Portland Brewery of Ashton-under-Lyne, and the Ardwick based Kay's Atlas Brewery. More empire building occurred in 1949 when Robinson's took over the 160 pubs owned by Bell and Company of Hempshaw Lane, Stockport. This continuing expansion necessitated new premises and eventually in 1973 work began on a bottling and packaging complex on a Bredbury site. This first phase was followed in 1982 by Phase Two when kegging was transferred to a newly constructed development. The company once more increased in size following a move in 1982 whereby over 56 houses belonging to Hartley's of Ulverston went to Robinson's.

In spite of modern technology, Robinson's still retains its traditional image, personified by two 17 cwt. shire horses who are often seen at shows and around Stockport, pulling a Robinson's dray.

The fourth generation of the Robinson family today consists of company directors, Peter, Dennis and David.

The beer

Several pubs owned by this brewery are described later, but what about the famous beverage they serve? Most of the hops come from Kent and south east England, while grain can be transported from places as far apart as Scotland and Norfolk. Water used for brewing the famous beer is drawn from boreholes some 600 feet in depth.

The brewing, fermenting and packaging operations are stringently checked, the company possessing a sophiscated laboratory where ingredients are tested to ensure they are of the highest standard.

The mild was the preferred drink of the 1950s, but today Robinson's best bitter proves to be the favourite with imbibers all over the north west and North Wales. Of course, there are other renowned tipples such as the powerful 'Old Tom' which is very high in alcohol. In fact, some Stockport landlords are reluctant to serve it in pint pots!

A major industry in Stockport, Robinson's brewery can be proud of over 150 years of unstinting work in producing high quality beverages.

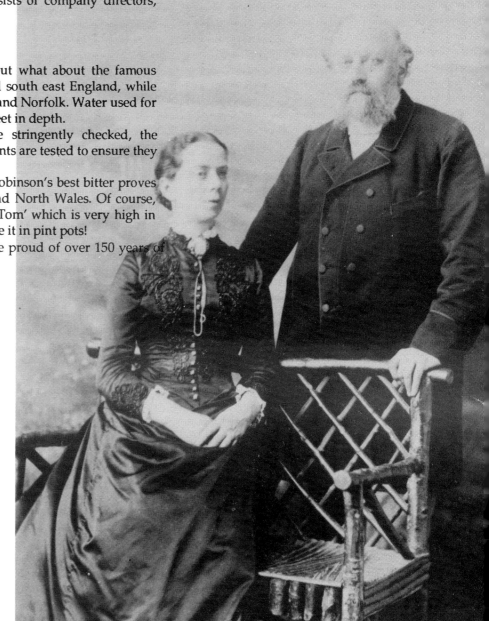

Mr and Mrs William Robinson pictured in 1888.

Examples of Pubs

'The Angel', Market Place

This pub once occupied a prominent position in Stockport's Market Place. Records indicate that the building was registered as far back as 1820, but the structure is much older than this.

It was the rehearsal venue for the Stockport Philharmonic Society during the 1820s and the pub was renowned for its drawing room. In addition to selling Bell and Company's ales, 'The Angel' also provided meals. The only legacy of the former pub are angels' heads on the frontage.

'The Arden Arms', Millgate

1988 was an important year in this pub's history, for after more than a quarter of a century, publican Jack May pulled his final pint in 'The Arden'. In March 1963 he became licensee of this traditional house whose gleaming furniture owed much to Jack's careful restoration. Perhaps one of the most intimate rooms is the snug which can only be reached by walking through the compact bar area.

There used to be an inn on this site as far back as 1709, while in 1760 a hostelry named 'The Arderne Arms' replaced 'Ye Brew Stoops Inn'. It should be remembered that Underbank Hall was not too far away (see Chapter Two), the town house of the Ardernes of Bredbury.

'The Arderne' brewed its own beer at one stage when owned by a Mr. J. Baker who sold it to Frederic Robinson's Unicorn Brewery in 1889. Today's 'Arden' still sells products from this brewery, and the busy, hospitable pub is a favourite for locals and shoppers.

'The Boar's Head', Market Place

'The Boar' is found just across the market place from the 'Baker's Vaults'. Demonstrating the architect's penchant for a Georgian style of building, this pub was at one stage owned by Worral's Brewery. Today 'The Boar's Head' sells beers from Samuel Smith's Brewery.

'The Buck and Dog'

This was built close to Lancashire Bridge and the original inn can be traced to 1790. It acted as a posting station when horse-drawn coaches flourished. In addition to this it was famous for some excellent decorations including the figures of a buck and dog plus several coats of arms from local families.

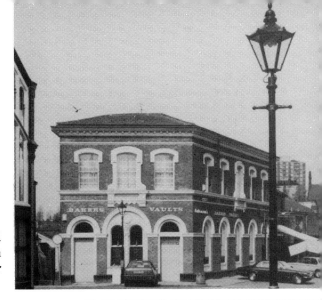

'Baker's Vaults', Market Place

Occupying a prominent place in Stockport's market place, the Victorian edifice acquired its name from the Baker family who owned it in the 1820s. Constructed in 1841, a building replaced an older one called 'The George and Dragon'. Today this popular Robinson's house is one of the main venues for live music in Stockport's pubs.

'The Blossoms', Heaviley

Once a Bell's Hempshaw Brook Brewery outlet, the 'Blossoms' stands on a busy corner at the junction of the A6 and Bramhall Lane. The name derives from a group of blossom trees which grew on the spot before the pub was erected in 1824.

The Robinson's pub was once a popular venue for employees of local hatting firms. This community pub with its unpretentious atmosphere underwent a huge redecoration process in 1993.

'The Davenport Arms', Woodford

A semi-rural hostelry located on the outer fringe of Stockport, close to the Cheshire boundary. It is a working farm pub where the family looks after the beer plus 30 ewes and 30 head of cattle.

A glance at the pub sign will reveal a man with a noose around his neck. This stems from the times when looting was a common crime in the area, and the Bromley-Davenport family dealt with culprits by hanging. This sign is a legacy from the family's crest and consequently the pub is often referred to as 'The Thief's Neck'.

This splendid Robinson's house contains several pictures of aircraft which is not surprising on considering the proximity of British Aerospace at Woodford (see Chapter Five). Popular with employees of this company and locals alike, 'The Davenport Arms' provides an outside drinking area, lunchtime meals, and a 'real' fire in front of which one can enjoy a superb pint of hand-pumped Robinson's beer.

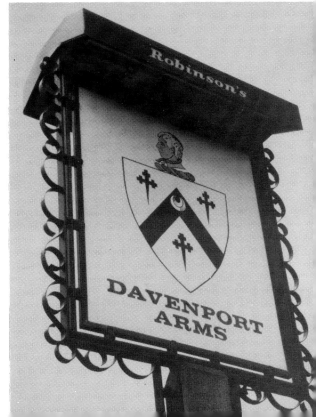

'The Emigration', Hall Street

What an odd name for a pub! So bizarre in fact that 'The Emigration' is the only pub in Britain to bear that name. The nearby New Zealand Road can provide a clue about this drinking place which was known as 'The Bull's Head' until the mid-19th century. It was about this time that local newspapers spoke of the many advantages of emigrating to the colonies. At this period local redundant millworkers claimed their wages were so low that they would prefer transportation to New Zealand - hence 'The Emigration', which became a popular haunt for these people as they discussed plans to move to the antipodes.

'The George', Compstall

People who have imbibed too much will look twice at the exterior of this pub which has a two-storey front and four-storey back and sides. The reason for this may be traced to the construction of the main Manchester - Derby road in the early 19th century. A pub called 'The Union' disappeared below street level, and later on it was decided to erect a pub on top of the existing inn. Consequently, today's 'George' features a two-storey front and four-storey back and sides. Its shape was governed by the previous structure.

While sipping a pint of Robinson's here it is worth considering that tunnels beneath the pub are believed to lead to the River Goyt, half a mile's distance. This charming place for a drink may have acquired its name from two sources - the reigning monarch at the time or George Andrews who was a local landowner.

'The George and Dragon', Hazel Grove

There has been a building on this site since 1780, but it is not clear when the licensed premises began trading. In the early 1830s one Ambrose Dransfield of 'The George and Dragon' was registered as a tollgate keeper, and Chester's Brewery bought the property in 1896. The real ale house was redecorated in the early 1990s.

'The Gladstone', Lower Hillgate

Originally named 'The Bishop Blaize', the public house played a crucial rôle in the infamous Stockport riots of 1852. It is believed that the first disturbances occurred in 'The Bishop Blaize', leading to riots in St. Peter's Square, Edgeley, Rock Row and elsewhere. Sentences passed on the rioters ranged from three months in gaol to transportation for 15 years! Today's pub is a quieter place where Burtonwood products are on sale.

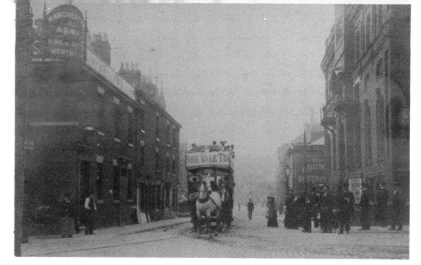

Top:

It is 1904 and a horse-drawn tram passes, 'The Manchester Arms' (left) on its journey to Hazel Grove.

Bottom:

Gladstone's censorious face peers down at imbibers who are about to enter the Lower Hillgate public house which was the scene of the outbreak of the 1852 riots. The disturbances led to a troop of Dragoons being sent from Manchester to assist local police and extra special constables who had to be sworn in.

'The Griffin', Didsbury Road

A Holt's house selling good beer whose price is very low compared with that on sale in neighbouring pubs. Built in 1831 by the Thorniley family, 'The Griffin' was purchased by Joseph Holt in the early 1920s. No trendy trappings here, but a tasteful bar area and a friendly atmosphere.

'The Hesketh Arms', Cheadle Hulme

Situated on a busy corner of the Cheadle Hulme - Cheadle road, this pub took its name from the Hesketh family who held the estate of Cheadle-Moseley from 1806. The Lord of the Manor, W.B. Hesketh, built the hostelry in place of the old village inn, 'The Horse and Jockey'.

'The Jolly Sailor', Woodsmoor

The first pub of this name was located just north of where Bramhall Lane meets Woodsmoor Lane. In the 1890s the area around the inn was called Charlestown, taking its name from a house at the junction of the two lanes. The present 'Jolly Sailor' is a late Victorian Building whose date stone bears the inscription, 'Rebuilt AD 1895'. It is a lively place catering in the main for younger drinkers - no dark corners and panelled walls in this pub!

'The Manchester Arms', Wellington Road

Opening in 1841, this was listed as 'The Cobden and Manchester Arms' in 1855 in recognition of Stockport MP Richard Cobden. The early 1990s brought a thorough facelift both inside and outside the pub.

Sandwiched between buildings on Princes Street, 'The Swan With Two Necks' receives much of its interior lighting from skylights instead of windows.

How many people remember 'The Red Lion' when tram lines ran in front of the pub?

'Chestergate Tavern', Chestergate

The original pub of this name was constructed in 1839 and later demolished for road widening purposes in 1896 when Stopford's Brewery built the 'Mersey Inn'. This is referred to on the date stone, 'Rebuilt 1896'. The former premises contained a six-barrel brewery in addition to being a pub, but this ceased in the mid-1860s when Stopford's took it over and provided their own beer.

'The Nelson Tavern', Wellington Road

Standing at the junction of Greek Street and Wellington Road, this hostelry was rebuilt in 1832. Brewing was carried out on the premises until 1849. 'The Nelson Tavern' has been the purveyor of a number of beers including Wilson's and Chester's. Today the pub sports the sign 'Chef and Brewer' and is a meeting place for students from the nearby Stockport College.

'The Nursery Inn', Heaton Lane

For those who appreciate a decent pint of Hyde's mild or bitter in a convivial atmosphere, then 'The Nursery' on Green Lane is the place to visit. Wood panelling is found throughout this little backwater and a bowling green is an added attraction during the summer months.

'The Printer's Arms', Cheadle

A traditional Robinson's house on Stockport Road, Cheadle, close to the end of the M63, 'The Printer's Arms' traces its ancestry to the end of the 19th century. It has undergone a number of transformations in recent times, although the vault still remains an intimate place which caters well for a large number of locals.

`The Red Lion', Hazel Grove

Sadly, this pub was demolished in the early 1990s. A plaque on the exterior wall read, 'Village of Hazel Grove 1796'. This emphasises the age of the pub and its importance as one of a number of coaching inns providing stabling for horses. Other examples of local places offering this facility were 'The Rising Sun', 'The Grapes' and 'The Anchor'. By 1755 there were nine inns on the main road, increasing to a dozen or so by 1824, including 'The Red Lion' whose owner was Mary Fidler. The public house played a prominent part in Hazel Grove's history. For example, in 1833 at the laying of a foundation stone for the parish church, the procession of ministers and officials began at 'The Red Lion'. Again, it was one of several offering its water pump for use by locals when drinking water had to be obtained from pumps or wells in the 1830s.

More recently, a county bowling match in 1931 took place at the pub whose green was reputed to be one of the best in the Stockport area. Cheshire beat North Derbyshire in this match.

'The Swan with Two Necks', Prince's Street

A popular watering hole in Stockport's centre, 'The Swan' is some 70 years old. Selling Robinson's mild and bitter this pub is long and narrow in shape. The interior comprises two rooms, a corridor and pleasant wood panelling.

'The Three Tunnes', Hazel Grove

Dating from the late 1700s this was one of ten pubs in Hazel Grove in 1820 when the owner was one James Moseley who owned a small brewery in addition to the pub.

In the mid-1860s it was taken over by Wheater and Swales Brewery. Today's 'Three Tunnes' is a hospitable spot with a friendly clientèle many of whom also try the beer next door at 'The Grapes' which has occupied its site for 350 years.

'Queen's Head', Underbank

Formerly called the 'Queen Anne' and more recently 'Turner's Vaults' this cosy pub was renamed the 'Queen's Head' in the early 1990s.

'The Victoria', Bramhall

In 1905 'The Victoria' was a red brick structure with black and white gables, built to replace an inn of this name on the same site. Standing at the junction of Ack Lane, Moss Lane and Bramhall Lane the pub had a row of houses next to it. These dwellings were known as 'Albert Terrace' in memory of the Prince Consort.

'The Victoria' was demolished in 1967 to make way for a shopping precinct. The present pub of that name does not reflect the rather splendid 'baronial' architecture of its predecessor. Today's 'Vic' is a smart popular meeting place selling Boddington's beer.

'The Wellington Bridge Inn', Wellington Road

This public house underwent a number of name changes over the years, one of which was 'Ups and Downs'.

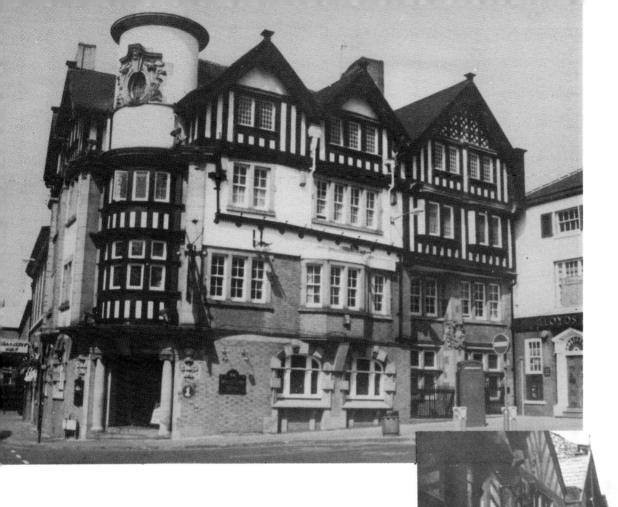

Today's 'White Lion' dates from 1904.

'The White Lion' is on the left of this 1892 scene of Great Underbank. A brewhouse operated on the premises in 1825 with beer production continuing until 1842. In the early 19th century, 'The White Lion' provided 14 rooms for overnight travellers and stabling for 21 horses.

Dating from 1826, the location of 'The Wellington Bridge' on the main road meant it was an important stop for many horse-drawn coaches. These included the 'Royal Mail' which went to London, and the Birmingham-bound 'Traveller'.

The inn sold beer brewed on the premises until 1860 or thereabouts, and it was about this time that Hall Street Brewery supplied ale from its Chestergate premises. Later, the pub came under the auspices of the Ardwick-based Manchester Brewery Company, famous for its 'Silver Vatted Ales'.

'The White Lion', Great Underbank

The pub has its origins in the 1400s with a building opening for business in 1743. The façade of this timber-framed structure was modified in 1832. Records indicate that a brewhouse existed on the premises in 1825, and beer continued to be made there until 1842. 'The White Lion' was an important coaching inn and posting house capable of accommodating two dozen horses in the 1820s. At one time the owner would fire a cannon in front of the hostelry in order to attract townspeople who would come to hear news from the town crier.

In 1904, the timber-framed pub was replaced by an elaborately decorated building reflecting the Edwardian penchant for ornate exterior fitments. Spring 1993 brought further alterations to the interior of the pub which now sells Whitbread products and cask ales.

'The Woodman', Hazel Grove

A popular Robinson's outlet on the busy A6, 'The Woodman' is possibly situated on the site of William Brewer's home at Brewer's Green. Records show that it was not until 1870 that a beerhouse began trading on this spot. The family run business was owned by the Simpson's from the 1870s until 1935 when it was sold to Robinson's Brewery.

Yates's Wine Lodge, Market Place

Occupying a corner position, Yates's Wine Lodge is well worth entering, if only to admire the fascinating interior décor which received a facelift in the early 1990s. Polished columns, classical statues and a cast iron and glass roof greet visitors who may be able to guess that this is not a purpose-built Yates's property. Dating from 1868, the premises were once the home of a bank.

Stockport public houses cater for all tastes and offer a wide selection of beer. Perhaps the words of 17th century Benedict Spinoza are a suitable way of concluding this chapter. In his *'Ethics, Part IV'* he comments *'It is the part of a wise man to feed himself with moderate pleasant food and drink...'*

8. Some Stockport Districts

Stockport is a good example of a medieval market town which changed to an industrial town in the 18th and 19th centuries. The growth of Stockport led to the occupation of the Underbanks, and later the mills became the focal point of local communities. For instance, there is a connection between houses on Brinksway and the Travis Street Mill, while Sir William Houldsworth played a major part in the development of Reddish where he provided a mill a several local amenities (see Chapter Five).

The town's 115,000 homes offer a variety of accommodation for residents who work in Stockport, or for commuters who take advantage of the proximity of the motorway network.

Settlements such as Bramhall, Compstall and Marple add to the diversity of life in the borough where one finds several residential districts close to Stockport's centre, like Brinnington and Heaton Norris.

In this chapter a selection of districts provides a good insight into various parts of Stockport. Reference is made to the origins of these places, buildings of note and their rôle in the borough yesterday and today.

Bramhall

One of the more salubrious suburbs of Stockport, Bramhall was a Saxon settlement before the Normans arrived and is referred to in the Domesday Book as 'Bramale'. This suggests Saxon origins since in Old English, 'brom' means a broom, while 'halh' is a nook or hidden place near the water.

The family living in this area took its name from the place, while the founder of the de Bromale family was probably a follower of Hamon de Massey.

In the time of Henry II reference was made to one Matthew de Bromale, while later people in the family included Alice who married John de Davenport of Wheltrough. She eventually inherited the Bramhall lands.

Of course, the name Bramhall conjures up thoughts of this majestic Hall found there, and this is described above in Chapter Two, 'Architectural Heritage'.

How many residents today know that a pub stood where the roundabout is found outside Bramhall Park? 'The Shoulder of Mutton' was in an area known as Bramhall Green and it later moved up the hill where it was renamed 'The Jolly Sailor'.

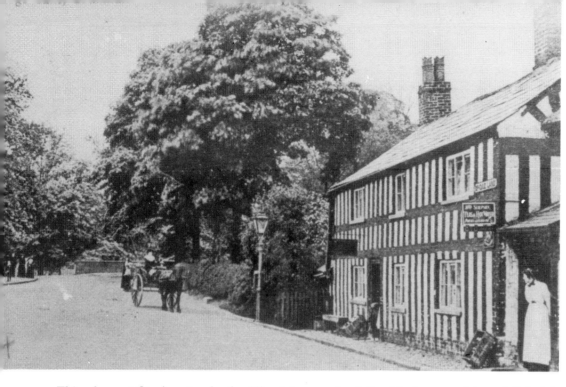

Bridge Lane, Bramhall as it used to be. The lady on the right looks out of her home which displays a sign announcing that teas and hot water are available.

This pleasant Stockport suburb still retains much of its old charm and is a delightful place to live. During early 1989 there were proposals for a large scale redevelopment of Bramhall Shopping Precinct, encouraged by the existence of shop premises which have remained vacant for several years.

Naturally various name changes have occurred in this township over the years. For example, in the 17th century Bridge Lane was referred to as Mill Lane which carried on right up to High Lane (Hazel Grove). In the mid-18th century there were some 540 inhabitants of Bramhall living in just under 90 houses, with the population increasing to 1,400 in 1831.

The Urban District of Hazel Grove-cum-Bramhall came into existence in 1900 and the Hall was sold to Mr. J. Davies in 1925. Ten years later it was purchased by the former Hazel Grove and Bramhall Urban District.

Various polemics surrounded the spelling of the Hall at this time when older residents referred to it as 'Brammull'. There had been no hard and fast rule about this, but the Council eventually decided that 'Bramall' would be used for the Hall and park, while 'Bramhall' was kept for the township.

Bredbury, Romiley, Compstall

It is probable that St. Chad visited this district in AD 670, giving rise to the name Chadkirk. Records of the 1300s speak of a chaplain at *'Chaddkyrke'*. Bredbury was held by a Saxon called Wulfric possibly until 1070 and the Domesday Book refers to 'Bredburie' and 'Rumilie'.

The district was home to a number of people in medieval times, including the Vernon, Arderne, Davenport and Bredbury families. During the mid-1700s just over 200 families resided in the Bredbury and Romiley areas, while records reveal that 1,181 people lived in this last place in 1821.

Some 1700 inhabitants could be found in the Compstall Bridge of the early 1830s, many of whom were engaged in calico printing, weaving and cotton spinning. Coal mining was also in evidence with over a dozen pits operating in Bredbury during the 1800s, and there were several instances of old workings collapsing.

Bredbury and Romiley merged in 1880 with Compstall joining them in 1936. This last township owes much to George Andrew who established mills in Compstall during the early 1820s, and built Compstall Hall on slopes above the River Etherow. The Etherow Country Park is described in Chapter Three. In addition to Compstall Hall, other buildings of note include Goyt Hall and Oakwood Hall. The former, an Elizabethan-framed structure, was erected at the end of the 16th century, while Romiley's Oakwood Hall was built for Ormerod Heyworth who owned, of course, Oakwood Mill.

Arden (or Harden) Hall, Bredbury was the home of the Ardernes, and it dates from 1597. They also used Underbank Hall as their town house (see Chapter Two).

Bredbury Hall is perhaps best known as a night club and it may come as a surprise to some revellers that in the mid-18th century it was used as a farmhouse.

Cheadle

There is evidence of a Roman settlement in this area, and it is clear that the Saxons set up a cross dedicated to St. Chad on the banks of the River Mersey. The name 'Cheadle' derives from this saint, and the village was big enough to be mentioned in the Domesday Book. In 1086 *'Cedde'* was two leagues long and one league broad with a wood one league in length and half wide. There were two ploughmen, four villagers and three smallholders, a deer enclosure or trap and a hawk's eyrie. It was a Saxon named Gamel who held the manor under his Norman lord, the Earl of Chester.

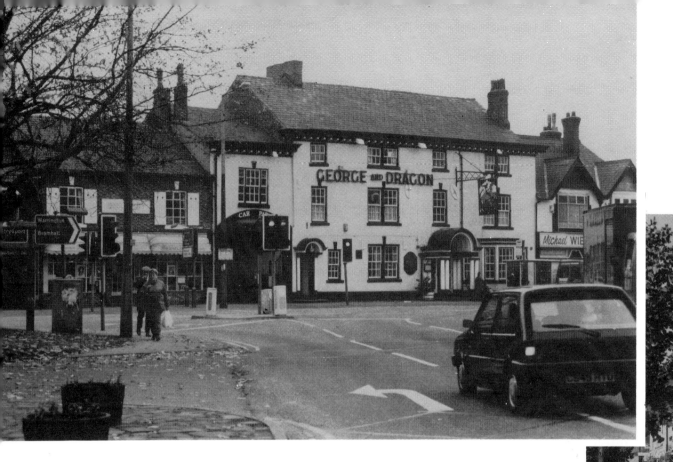

Today's busy junction at Cheadle is still dominated by 'The George and Dragon' where brewing continued until 1867.

These quaint Compstall cottages overlook the Etherow Country Park.

During the early 14th century the Manor of Cheadle was divided between the two daughters and co-heiresses of Sir Roger de Cheadle, Clemence (wife of William de Bagulegh) and Agnes (wife of Richard Bulkelegh). Agnes received the area now known as Cheadle, while Clemence was given lands in today's Cheadle-Hulme area.

The Cheadle parish of the 1820s embraced Handforth, Cheadle-Moseley and Cheadle-Bulkeley. The parish population was 6,500 in 1821 and 8,150 ten years later. This rose to 10,840 in 1851, of whom just under 6,000 resided in Cheadle itself.

During the mid-19th century Cheadle was a rural community with some evidence of various industries within its boundaries. Records indicate that cornmills were situated alongside the River Mersey, while printing works also existed in the area. There were just over 100 farms in the Cheadle of the 1860s and it is interesting to observe that at this time half the working population was employed in the textile industry. Handloom weaving had flourished in the district for two centuries and silk weaving proved a popular occupation.

Buildings of note include St. Mary's Church and Abney Hall (see above). Residents of Cheadle have been provided with a good selection of hostelries for some time. Records of the 1830s show that 'The Crown' was owned by William Davies, 'The George Inn' by William Evans, and one Edward Parkinson ran 'The White Hart'.

With Manchester's centre just seven miles away, Cheadle has become a popular home for commuters. Some of the original village identity has been lost, but this busy little place still retains a character of its own.

Cheadle Hulme

The Romans may have occupied this area, since their coins and a bracelet have been found in the vicinity of Hulme Hall. The Angles and Saxons also resided here (see Cheadle). Records show that the Manor of Cheadle was divided in 1327, and the wife of William de Bagulegh acquired land which was in the present Cheadle Hulme, an area in which there were a number of small hamlets such as Hulme Hall and Smithy Green.

'Chedle Hulme' then passed through a succession of people including the Savage family of Rocksavage and the Marquis of Winchester before being purchased by the Moseley family in the mid-17th century after the sequestration of the latter's estates in the civil war - hence the alternative name 'Cheadle-Moseley'. Other owners were the Hesketh and Vernon families, and 'The Hesketh Arms' public house in Cheadle Hulme is a legacy of the first mentioned family.

Like Cheadle, the present day Cheadle Hulme is part of the Stockport conurbation, comprising mainly private houses.

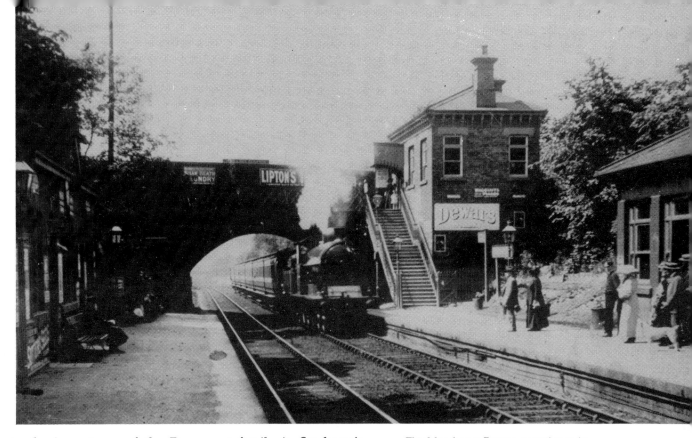

Davenport

This suburb's name reflects the importance of the Davenport family in Stockport's history. The origins can be traced to Orm de Davenport. Davenport or Dauen-port was also the name of a village near Congleton. During the 14th century branches of the Davenport family established themselves at Henbury, Woodford, Wheltrough and at Bramhall.

Modern Davenport is reached by proceeding down Bramhall Lane from 'The Blossoms' public house, while Davenport Park occupies an area between Bramhall Lane, Kennerly Road and the A6.

Davenport is a quiet residential area with long established housing. Commuters to Stockport and Manchester use Davenport Station from where trains also run to Buxton. The district was not provided with a station when a line ran through Davenport. Following requests from one Colonel William Davenport, a station was added on the Stockport - Whaley Bridge line, opening in 1858, closing the following year and re-opening in 1862.

This Manchester-Buxton excursion train prepares to stop at Davenport Station on its way to the Peak District. Advertisements encourage travellers to try Lipton's Tea, Dewar's whisky and the Shaw Heath Laundry.

A quiescent view of Hazel Grove before traffic lights appeared at 'The Rising Sun' junction. The road to the left leads to Disley.

Hazel Grove

Does the name Bullock Smithy mean anything to you? This was the area occupied by modern Hazel Grove. In the 1830s Bullock Smithy was described as a collection of houses in the parish of Stockport, where local residents were chiefly engaged in the weaving of silk and cotton.

One Richard Bullock was awarded the lease of a smithy in 1560, and it is likely that the townships of Bosden, Torkington and Norbury were eventually given the collective name of Bullock Smithy around 1600. This title remained until the late 1830s when the district became known as Hazel Grove. But what about the etymology of this name?

Well, during the 17th century reference was made to a Hessel Grave hamlet on High Lane. This was located just past today's railway bridge going towards Disley from 'The Rising Sun' public house. The place underwent several changes in spelling over the years with 'Hesselgrave' becoming one word. In the late 1700s it disappeared from maps, possibly because people moved the short distance to Bullock Smithy. Here, an inn called 'The Hazel-Grove' began trading in 1820 and gradually the title Hazel Grove was given to this district during the 1830s.

A few houses had been built alongside roads on the eastern part of the village by 1840, for example, at Smithy Lane and Vernon Street. Hazel Grove railway station began business in 1857 as a stop on the Stockport - Whaley Bridge line, while 1890 first saw horse-drawn trams plying the route between 'The Bull's Head' and Stockport. In addition to this Grove hostelry, residents could enjoy a drink at a number of public houses in the early 1900s. Popular haunts at that time included 'The Anchor', 'The Grapes' and 'The Three Tunnes'.

The parish of Hazel Grove-cum-Bramhall was inaugurated in 1900 at a time when there were some 6,600 inhabitants in the Grove. This had risen to approximately 10,000 by 1936. When the Urban District Council was abolished in 1974, Hazel Grove became part of the Metropolitan Borough of Stockport within the Greater Manchester County.

The Heatons

The Old English *'Heatun'* means 'a place situated on high land' and Stockport has several districts containing 'Heaton' in their name.

Heaton Norris

The Heatons were a separate manor from Stockport and were given by Henry II to one William Norreys from Lancashire - hence the name Heaton Norris.

Formerly in Lancashire, Heaton Norris was divided from Stockport by the River Mersey. When Stockport's population was 33,556 in 1821 there were 6,958 residents in Heaton Norris, this number rising to 11,258 ten years later.

June 1840 brought the Manchester (Travis Street) - Heaton Norris railway link, with trains on this five-and-a-half mile long route stopping at a small building in Heaton Norris. The completion of the viaduct (see Chapter Two) contributed to the demise of the station which was replaced by one at Edgeley. Rail traffic began using this in 1843.

Heaton Chapel

Documents of the 1830s show that within the township of Heaton Norris an 'elegant new chapel, called 'Heaton Chapel" was built by subscription. This district straddles the A6 between Heaton Moor Road and the Manchester boundary at Crossley Road. Heaton Chapel contains a mixture of small industrial estates plus large companies like Fairey Engineering, together with considerable private housing.

Cobbled streets in the Heaton Norris area have a certain charm of their own.

Bygone Heaton Chapel when 'The George and Dragon' was a Clarke's public house before its acquisition by Boddington's. The corner shop's sign reads, 'John Williams and Sons Ltd., the Suburban Grocer'.

Heaton Moor

The suburb takes its name from a large tract of open moorland called Heaton Moss, the district owing a great deal to the Manchester and Birmingham Railway which dated from the 1840s.

By 1850 there were some 15,000 people living in the area with the nearby Heaton Chapel Station used regularly by commuters to Manchester and Stockport. Opened in 1852, this station was renamed Heaton Chapel and Heaton Moor in January 1916.

The 120-year-old Heaton Moor Methodist Church, a local landmark, was demolished in December 1988 to make way for a new purpose-built two-storey premises at a cost of £580,000, opening in Summer 1989.

Heaton Mersey

For some time the district was administered by Heaton Norris. Heaton Mersey had a population of about 1,500 in 1853. This had risen to just over 2,000 in 1881. Among the district's famous residents was the merchant James Watt, who lived in Heaton Villa and West Bank House before moving to Abney Hall, Cheadle.

Heaton Mersey's workforce could be found in a variety of places, including the local brickworks and bleachworks at the river end of Vale Road. Some popular haunts for 19th century residents are still evidence today - for instance, 'The Crown Inn', at the top of Vale Road and the 'The Griffin' public house. The former first began trading in a row of cottages, whilst 'The Griffin' was built by the Thorniley family.

Marple

Once referred to as 'Merphull', this area is not mentioned in the Domesday Survey. However, there are records relating to the place as early as the 12th century. It was about the year 1220 that Randle de Blundeville, Earl of Chester, granted Marple and Wibersley to Robert, son of Sir Robert de Stokeport. A large portion of lands in this charter were regranted by Sir Robert de Stokeport to his sister who was married to William, son of Richard de Vernon. These then passed to various people including the Stanleys and the Hibberts.

Marple Hall (no longer in existence but dating from the 16th century, though most of it was 17th century) was bought by Henry Bradshaw, yeoman, in 1606 from Sir Edward Stanley. One of Henry's grandsons, John, was one of the famous (or perhaps infamous) people of Marple. He was a well-known Cheshire lawyer and supporter of Parliament in

Marple locks on the Peak Forest Canal which joins the Macclesfield Canal in Marple.

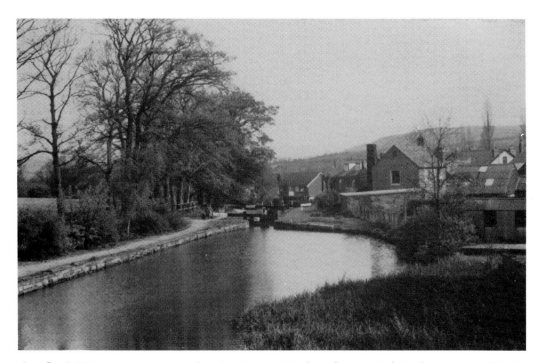

the Civil War period. When Charles I was tried and executed in January 1649 John Bradshaw was Lord President of the High Court and his judge. Bradshaw died in 1659 and was buried in Westminster Abbey but with the Restoration in 1660 his body was exhumed and his rotting skull stuck on a spike on top of Traitor's Gate at the Tower of London, along with that of Oliver Cromwell and other regicides.

Judge Bradshaw's elder brother, Henry, was an officer in Colonel Robert Duckenfield's Parliamentary Regiment at the start of the Civil Wars, commanding his own regiment by the end nine years later.

Marple stands at the junction of the Peak Forest and Macclesfield Canals. The former's construction was encouraged by Samuel Oldknow who opened a muslin factory in Stockport (1785) and a cotton mill in Marple (1790). Seven years later Oldknow built lime kilns on Strines Road, with limestone and coal transported to the kilns on two branches of the canal which ran from the Marple basin. Oldknow is also credited with rebuilding All Saints Church, Marple, between 1808 and 1812. The Peak Forest Canal was constructed on two levels - one from Dukinfield to the River Goyt, the other from Marple to Buxworth. In Marple one finds a flight of 16 locks which link the two sections while a stone aqueduct carries the canal over the Goyt.

Like most of the southern part of the metropolitan borough of Stockport, Marple once stood in Cheshire, but following changes in boundaries some 16 years ago, it is now part of Greater Manchester County.

Reddish

Not surprisingly, there was a Reddyshe family whose ancestry can be traced to the 13th century. They resided in Reddyshe Hall which was a black-and-white building. Both family and district have been variously called Rediche, Radich and, of course, Reddish.

During the late 18th century some 340 people lived in the area, this number rising in 1800 to 450. By 1822 Reddish occupied 1523 acres and had a population of 2519. Locals found work in a number of industries such as bleaching, making hats, weaving and in cotton mills. Records indicate that a corn mill existed in 1657 near a river called the 'Tame' or 'Redich Water', where local inhabitants took their corn for grinding.

Reddish was considerably affected by the opening of the Manchester and Ashton Canal in 1797. In addition to providing locals with a passenger boat service to Stockport or Manchester, the waterway found favour with cotton mill owners. By constructing their premises alongside the canal they had a ready supply of water which could be used for a variety of purposes including cooling machinery. It has been mentioned in Chapter Five that several mills existed in Reddish. Some examples would be the Albert Mills (1845), Houldsworth Mill, Coronation Mills and the Broadstone Mill.

In addition to the canal, Reddish also received a boost from railways which serviced the district. In 1849, for instance, the London and North Western Railway ran a line from Stockport to Guide Bridge via Reddish, while the Manchester, Sheffield and Lincolnshire Company put a route through Reddish North Station in 1875. The Great Central line was finished in 1892, running from Chorlton Junction to Fairfield with a stop at Reddish.

A popular event for locals was the building of the new Reddish baths, library and fire station, with the official opening taking place on May 7th, 1908. Three years later Reddish was incorporated into Stockport at a time when 14,200 inhabitants lived in the suburb.

A walk round Reddish will reveal several examples of Sir William Houldsworth's work in the district. Together with Robert Hyde Greg, this man did much to form the character and appearance of Reddish. Houldsworth's mills and the Church of St. Elisabeth are mentioned in earlier chapters, and his name is perpetuated by the construction of Houldsworth School and Houldsworth Working Men's Club. Today's busy square bears his name and is overlooked by 'The Houldsworth' pub.

Places

1 The Town Hall

2 The War Memorial and Art Gallery

3 The Central Library

4 Underbank Hall

5 The 'Three Shires'

6 The Old Rectory

7 'The Thatched House'

8 Cobden's Statue

9 The Parish Church

10 St. Joseph's Church

11 St. Peter's Church

12 Robinson's Brewery

13 Samuel Oldknow's house

14 Carr Valley

15 Original site of Stockport Grammar School

16 St. Thomas' Church

17 Infirmary

18 Stockport College of Technology

19 Railway Station

20 Merseyway Shopping Precinct

21 Bus Station

Street map